MIXED MEDIA
REVOLUTION

CREATIVE IDEAS AND TECHNIQUES FOR REUSING YOUR ART

By Darlene Olivia McElroy and Sandra Duran Wilson

NORTH LIGHT BOOKS
Cincinnati, Ohio
createmixedmedia.com

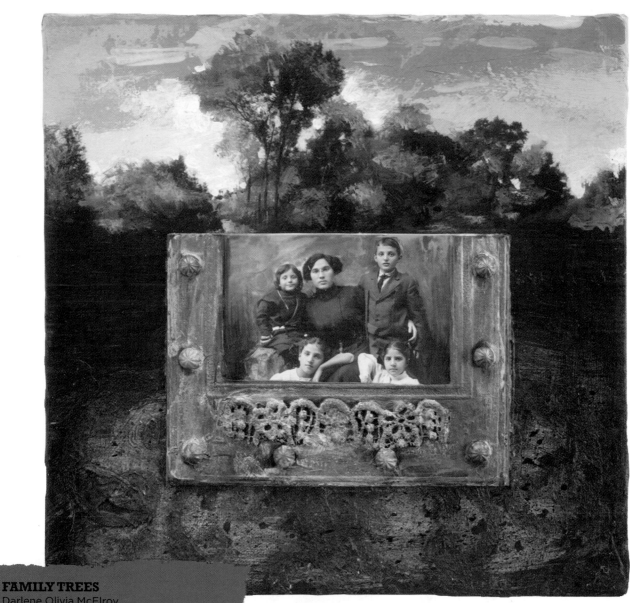

FAMILY TREES
Darlene Olivia McElroy
Featured Technique: Color Theatrics,
Drama—High Tech (Chapter 8)

To visit the **Mixed Media Revolution companion page**, scan this QR code with your smartphone or visit createmixedmedia.com/mixed-media-revolution.

Table of Contents

INTRODUCTION

Mixed Media Revolution will shake up the way you make art!

We all know the creative process can result in many leftover extras, stuff like transparency transfers, scraps and used paper towels. This book will have you reusing, repurposing and reinventing by using these leftovers in creative ways. Making art can be like finding the right puzzle pieces to go together, and this book will help you put together those pieces in a whole new way. The concept for this book takes its inspiration from our first two books, **Image Transfer Workshop** and **Surface Treatment Workshop**, as well as all those bits and pieces leftover from our many experiments.

We play around a lot with texture and transfer materials, and as a result we end up with a lot of leftover stuff that is just too cool to throw away. When that stuff is repurposed, not only will you be saving the planet but you will be learning some new tricks you never thought of before. Like reusing the leftover backing paper from fusible webbing that has been painted. You might just find this "leftover" piece to be more interesting than the web you painted and used. You will learn how to reuse it, morph it and change the color and scale of it. This book will also provide techniques for working with composition, perspective and color. Being a double agent isn't about espionage; it's about adding depth and dimension to your art by painting on both sides of clear acrylic sheets, like Plexiglas. You will learn wonderful ways to use scanners and copiers and how repetition and scale can enhance your composition. Your crackled surface can become a new surface when it is enlarged, and we will even have you cutting up your artwork and weaving it into something entirely new.

This book will inspire you to push the limits of your comfort zone and turn your work upside down (literally!). We will share tips on how to collaborate with other artists as a way to add on to your work. We had a hilarious time with Tango for Two and dancing with the paint using the music as inspiration and our feet as brushes (see Chapter 6). There is even a video outtake online (visit createmixedmedia.com/mixed-media-revolution to watch it). We think you'll enjoy trying this yourself!

This book also includes suggestions for additional techniques that will provide further inspiration. A greater focus lies on ideas than technique, but we do run you through all the different transfer and texture techniques that we use (some of them will be found online—visit createmixedmedia.com/mixed-media-revolution). We are always inspired by our readers, our artist friends and colleagues and, of course, our students. We had a lot of fun coming up with these ideas and hope you will take these concepts and run with them. Explore and experiment and dare to be different.

To view the **Tango for Two video outtake**, scan this QR code with your smartphone, or visit createmixedmedia.com/mixed-media-revolution.

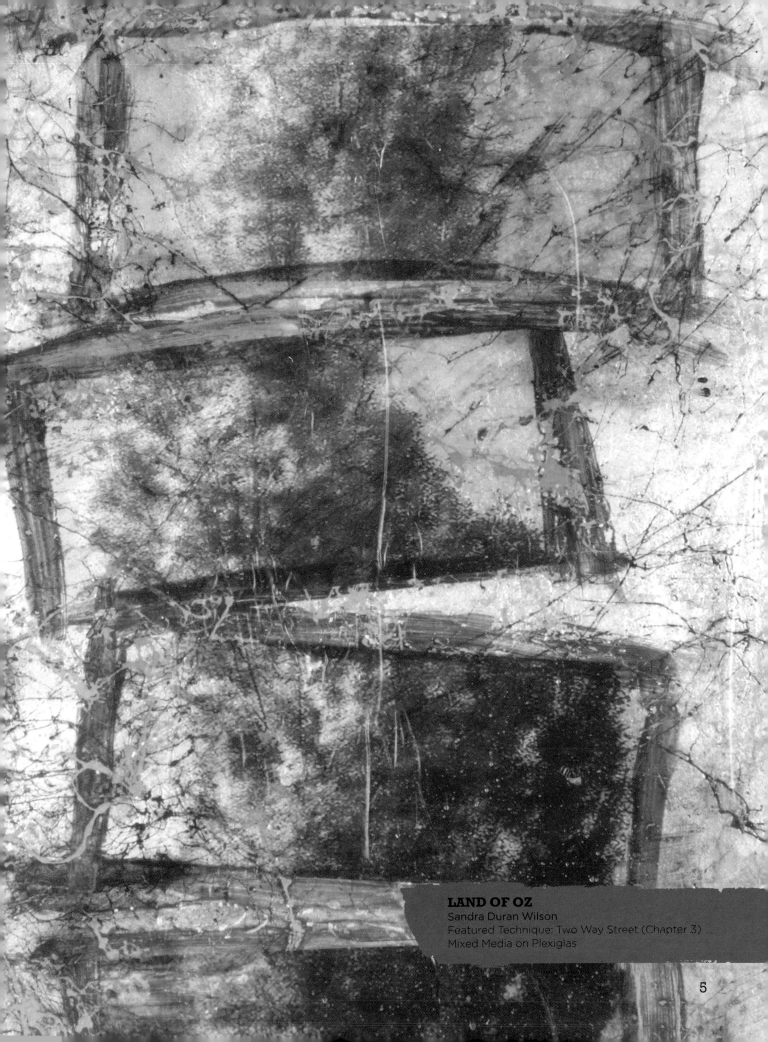

LAND OF OZ
Sandra Duran Wilson
Featured Technique: Two Way Street (Chapter 3)
Mixed Media on Plexiglas

How to Use This Book

Mixed Media Revolution contains much more than how-to techniques. We provide inspirational ideas, studio tips, suggestions for repurposing just about everything and even techniques for completely reinventing your art. We provide the tools for you to embark on your own creative journey and ideas for connecting with other artists and groups. The chapters are divided into concepts, like changing scale and working with copiers and scanners and playing with color and composition. You may want to select one idea from each of a few chapters and base a painting on those ideas. Or throw a party and put a few page numbers into a hat. Each partygoer tries a different technique before passing the piece onto the next person. Oh, the ideas are endless. We just want you to create and have fun.

And speaking of having fun and creating, well, during the making of this book, we did both. In fact, we had so much great content for this book, you could say it was overflowing. And, unfortunately, we only have so many pages to work with. Something had to go. We didn't want you to miss a thing, so we've created this great companion web page that will house everything we couldn't fit into the book. Throughout the book you will discover a bunch of Quick Response (or QR) codes like so many little treasures. Scan these codes with your smartphone (or type the accompanying web address into your web browser) for access to exclusive companion content, including tips and tricks, variations, additional tutorials, videos and more.

To visit the **Mixed Media Revolution companion page**, scan this QR code with your smartphone or visit createmixedmedia.com/ mixed-media-revolution.

Tools and Materials to Get You Started

While the techniques in this book use a variety of materials to create innovative surfaces, we make good use of some basic tools and materials you can probably find in your home or studio. Some of those items include:

- eyedropper
- newspapers
- plastic sheeting
- paints
- paintbrushes
- palette knife
- paper towels
- sandpaper
- scissors
- spray bottle
- stamps
- stencils

Don't let this list limit your creativity. As you'll see when you get deeper into the book, we love using what is on hand, and we love being creative with existing materials. Consider using what you already have, and see what happens to your art.

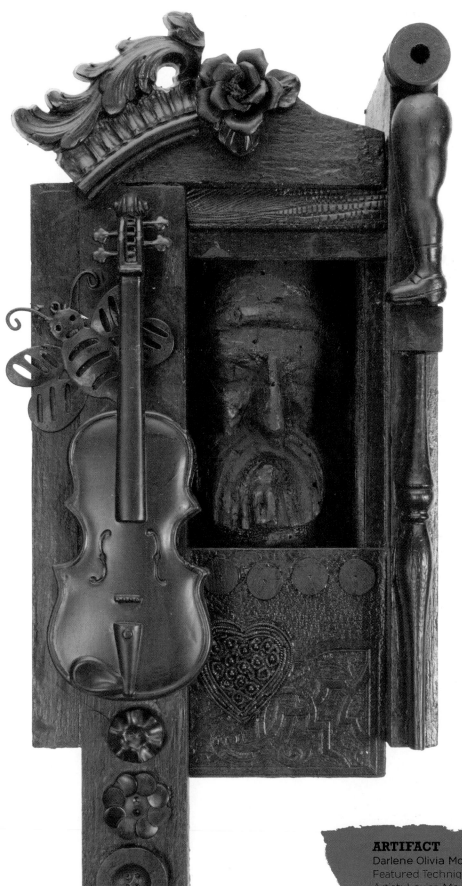

RECYCLE, REUSE

Be green: Reuse and recycle everything you can!

Mixed-media artists are the original green artists. Nothing goes to waste. How often have you picked up something off the street—like a used Metro ticket—and ended up pasting it into your art? How many times has the paper towel you used to wipe your brush become a collage element? Lots, I bet.

The pack rat in us saves labels, paper scraps, rusty bottle caps, used transparency transfers and old works of art in anticipation of the day that this bit of ephemera will become the perfect addition to the next art project. You can honor the stories, and all those who have touched these objects, by incorporating such things into your art, and you can save space in the landfills by recycling your leftovers.

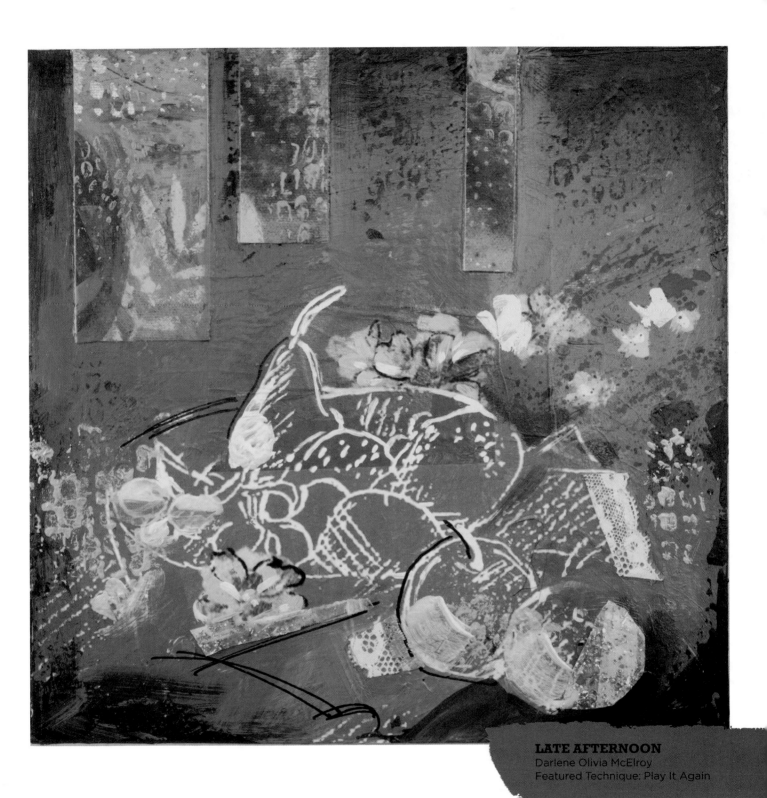

LATE AFTERNOON
Darlene Olivia McElroy
Featured Technique: Play It Again

Seeing Double

Double the use of a transparency after the image has been transferred. A ghost image left on the transparency can be used as a collage element. Save them for future projects, if you don't have an immediate use in mind.

TECHNIQUE ONE: GLUE IT

The ghost image left over after transferring your inkjet transparency image can add another layer to your collage.

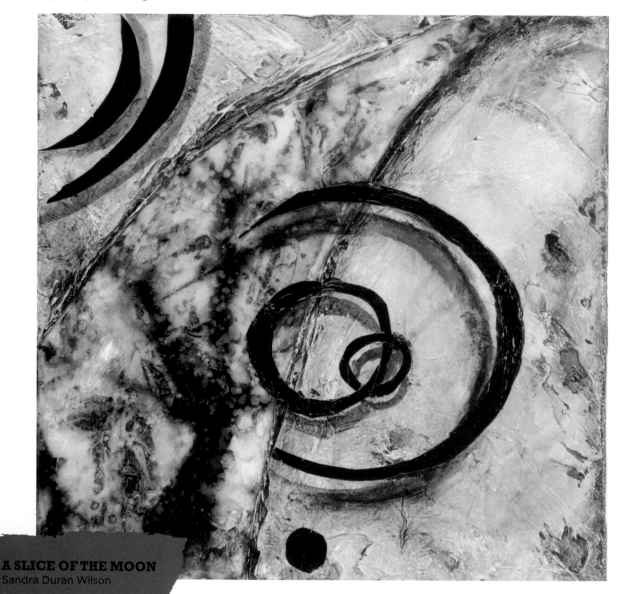

A SLICE OF THE MOON
Sandra Duran Wilson

1 Spray the used transparency with a workable fixative, and glue to your surface with polymer medium or soft gel.

2 For a more watery technique, don't spray the transparency with fixative—just go ahead and glue it down with medium or gel.

3 If you glued your transparency printed side down, you can sand the surface or apply some clear gesso over the surface to create a matte look, or paint over the top.

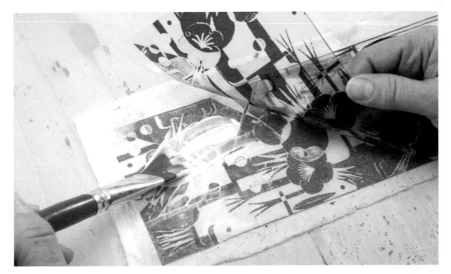

For a variation, brush glue over the transfer you just made...

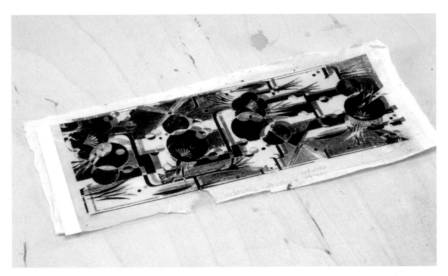

... then offset the ghost transparency slightly as you adhere it so you create a shadow.

TECHNIQUE TWO: EMBED IT

Layer the transparency between two layers of gel or resin so it appears to float. (Be sure to allow the first layer of gel or resin to dry completely before applying the second layer.)

TECHNIQUE THREE: ATTACH IT

Staple or sew the transparency to your art for a more industrial look.

TECHNIQUE FOUR: PAINT IT

Because the transparency is clear, you can paint the back of it to create colored or opaque areas before gluing it down.

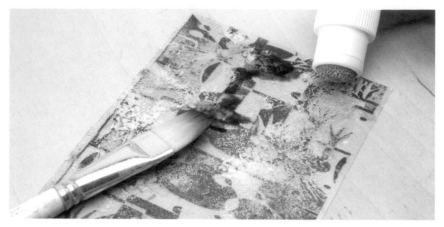

1 Paint parts of the back of the transparency. Let the paint dry thoroughly.

2 Using polymer medium, soft gel or adhesive film or spray, glue the painted transparency, painted side down, to another surface.

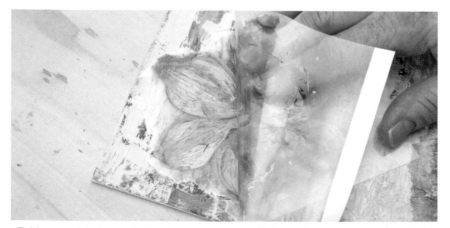

3 You could also pull the transparency off the substrate once the glue has dried. (This may take several weeks.) The paint and residual ink will have adhered to the glue and will resemble a decal.

Play It Again

Do you have an old piece of art that may not reflect your current style, or maybe it was an exercise, or an old canvas you found at a secondhand store? Give it new life by cutting it up and adding it to one of your paintings.

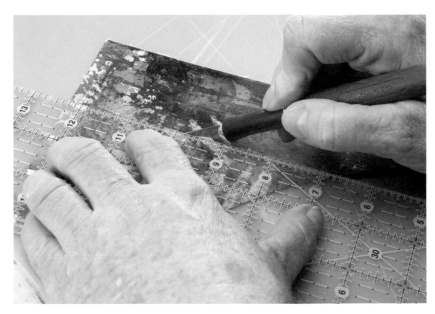

1 Maybe there is a part of the work that you love. Cut out that part and use it in a new project.

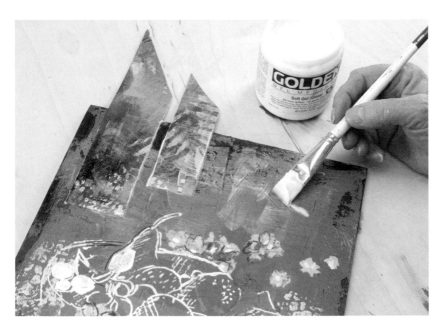

2 Glue such pieces onto your new surface using acrylic medium. Voila! You have just recycled!

TIPS

- Secondhand stores are great places for finding inexpensive paintings. Create a series with cut-up velvet paintings or some similar funky style.

- You can get paintings online or at flea markets for cheap. Use them as a background to reuse and rework.

- We all have old paintings we can give away or just don't want. Try trading with friends, and use parts of their paintings to enhance your new creations. You may want to apply gesso over parts and paint over seams to incorporate both paintings into one.

Yummy Leftovers

Our grandmothers knew how to reuse everything, including dinner leftovers. Why not do the same with your art leftovers? Use it again, whether it is the plastic wrap or salt that you used for creating texture on your art. Here are some ideas to get you warmed up.

TECHNIQUE ONE: STAMP IT

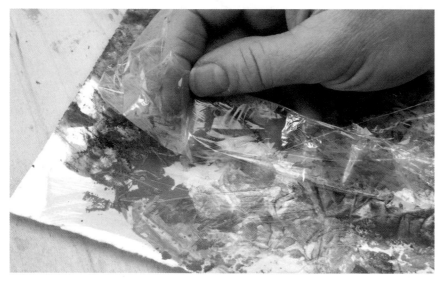

Take the plastic left over from doing a plastic wrap technique and stamp the still wet residual paint onto another surface.

TECHNIQUE TWO: TRANSFER IT

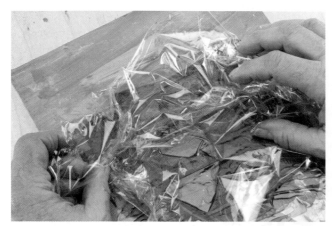

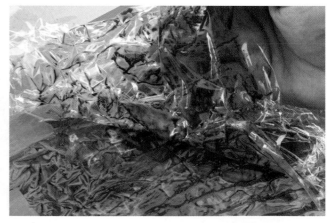

1 If the paint residue that remains on the leftover plastic wrap is dry, paint some polymer medium onto your art surface. Then, while the medium is still wet, lay the plastic wrap down, rub to ensure contact, and let the paint and medium dry completely.

2 When the paint and medium are dry, lift the plastic wrap off your surface. The residual paint will have transferred.

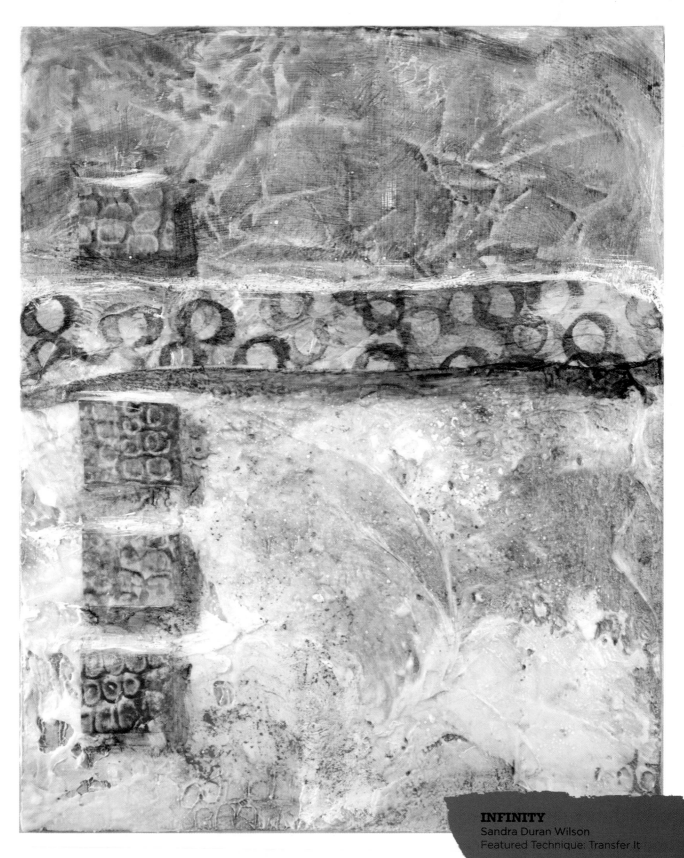

INFINITY
Sandra Duran Wilson
Featured Technique: Transfer It

For **additional variations on Yummy Leftovers**, scan this QR code with your smartphone or visit createmixedmedia.com/mixed-media-revolution.

Backward Thinking

Have you ever used a blender pen or Crystal Clear spray on a toner-based image? After you made the transfer, you may have discovered a wonderful ghost-like image on the back of the paper. Don't toss it—you can use this in a new piece of art. You can resize it, make transfers with it or use it in a collage. You get two pieces for the work of one.

TECHNIQUE ONE: TRANSFER IT

Our first book, **Image Transfer Workshop**, is a great resource for all things transfer. Our example here is created using a dry gel transfer and requires a toner-based image.

1 Apply polymer medium or gel to your surface.

2 While wet, lay your image face down and brayer flat.

3 When thoroughly dry, lightly sand the paper to scuff the surface.

4 Spray with water and rub off the paper. You may have to repeat this step several times to remove all the paper. Let dry completely each time you spray so you can see if the white paper haze is gone. Finally, lightly dampen your fingers (do not add water directly to the image at this point) and rub to remove the last layer of paper.

TECHNIQUE TWO: RESIZE IT

Scan your piece of art or take it to your local office store for a photocopy enlargement (toner base).

TECHNIQUE THREE: GLUE IT

1 Cut up your image.

2 Apply glue to your surface.

3 Lay down the collage element and use a brayer to flatten it.

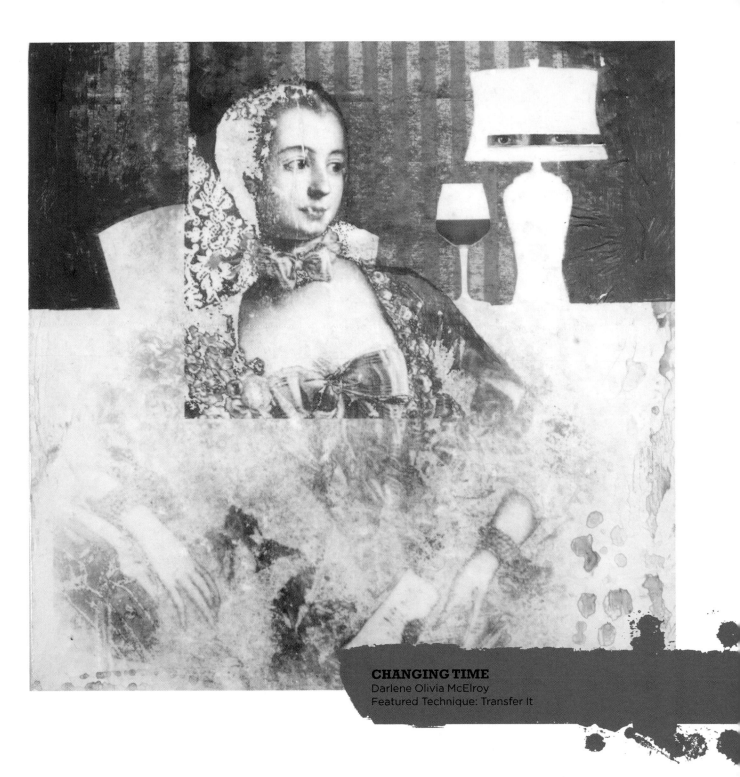

CHANGING TIME
Darlene Olivia McElroy
Featured Technique: Transfer It

For more information on **Image Transfer Workshop**, scan this QR code with your smartphone or visit createmixedmedia.com/ mixed-media-revolution.

Street Sweeping

Next time you take a walk, look down and see what you can find. Over time, the story goes, one man collected enough money to take his wife on a second honeymoon. An old friend of ours is a fanatical collector of rusty objects and bottle caps that she makes into exquisite objects of art. Call me crazy, but I find rust as alluring as gold leaf. In fact, I tend to rust many of the things I find on my walks, like buttons, bottles and keys. Create a whole art piece, use your objects as embellishments or turn them into jewelry.

TECHNIQUE ONE: GLUE IT

Use the appropriate glue for small rusty objects. For larger elements, a two-part epoxy is best.

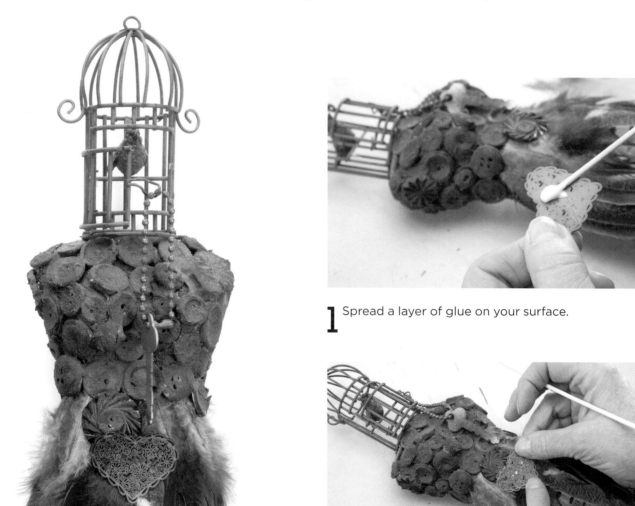

1 Spread a layer of glue on your surface.

2 While the glue is wet, lay your objects on your surface and press gently to bond. Allow the glue to dry completely.

FLIGHT
Darlene McElroy

TECHNIQUE TWO: EMBED IT

You can use mortar, molding paste, pumice gel or ceramic stucco as your glue. These mediums can all be tinted with acrylic paint.

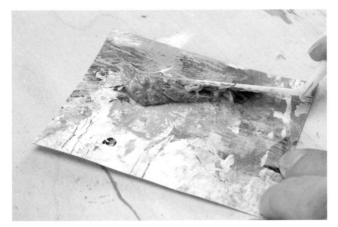

1 Apply mortar, molding paste, pumice gel or ceramic stucco to the surface.

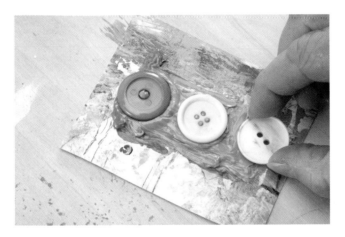

2 Embed your objects into the adhesive while it is still wet. Let the adhesive dry, and then continue to paint or embellish as desired.

TECHNIQUE THREE: SEW IT IN

Imagine a rusty but delicate piece of art hanging in your window. The shadows and colors would change during the day. If the piece is hung outside, it will rust even more due to exposure to the elements.

1 Sew rusty objects in pockets between two layers of light all-natural fabric.

2 Lay on a sheet of plastic and spritz with water or vinegar. Add salt to speed the rusting process.

TIP
Add variety by hanging your piece after you've sewn it into your fabric. Then do step 2—the result will be more of a drip-like effect. Do this outside where you won't damage any surfaces or plants, if possible.

For more information on **the rusting technique mentioned in step 2**, scan this QR code with your smartphone or visit createmixedmedia.com/mixed-media-revolution.

19

Instant Gratification

The battle cry of every mixed media artist is **nothing goes to waste**. Save those paper towels that you have wiped your hands and brushes on and you will find that at the end of the day you have a beautiful collage element. If you have multi-ply towels, separate the layers—you'll get multiple collage elements.

1 Paint randomly on the paper towel. Let the paint dry.

2 Stamp (or draw) on the paper towel. Let the ink (or paint) dry.

3 Glue the paper towel onto another surface using polymer medium or soft gel. Continue painting and embellishing, if desired.

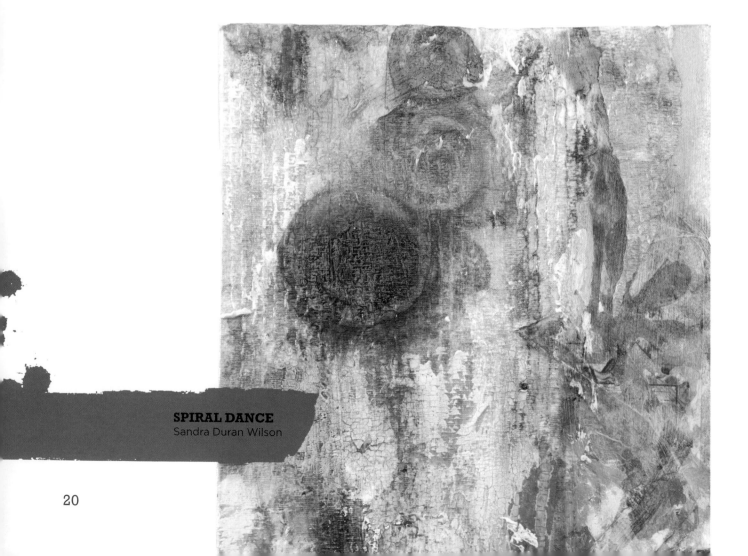

SPIRAL DANCE
Sandra Duran Wilson

Be Green

Mixed-media artists are known to save everything from labels, old envelopes, magazines, scraps of paper, things we pick up off the street, etc. Yep, ephemera. All that transitory written and printed matter not intended to be retained or preserved. Enter the mixed-media artists to reuse almost everything imaginable. Sometimes you may get carried away and glue everything down at once. If you end up with a busy background and need to tone it down or unify it, here are a few ways you can do so.

TECHNIQUE ONE: WASH IT

Tie all your elements together with a gesso wash or a paint wash.

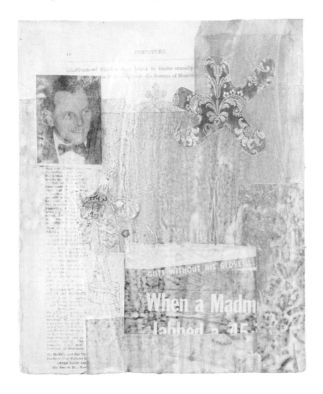

1 Thin your gesso or paint with water to your desired consistency.

2 Paint a thin layer of watered-down gesso or paint over your dry collaged surface. One coat will usually do the job; you want the collage to show through.

3 Add interest to the gesso layer by splattering water on it, letting most of the water dry, and then blotting the remaining water.

TECHNIQUE TWO: FOG IT

Create a foggy surface over the collage and make it mysterious with a faux encaustic layer.

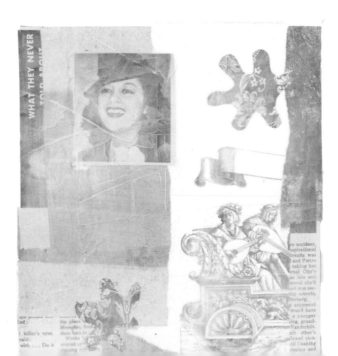

Spread a layer of matte gel over the surface of your ephemera-collaged surface. When the gel is dry, you can continue to work the surface as desired.

21

TECHNIQUE THREE: CRACKLE IT

Give your art a crackle finish that allows you to see the layers underneath.

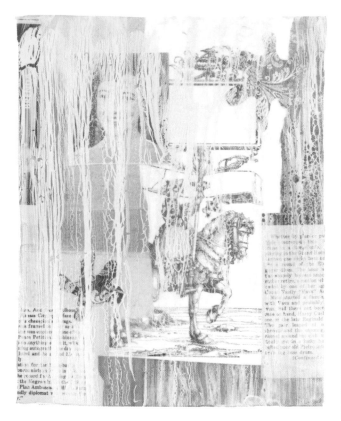

1 Spread a layer of white craft glue over your dried collaged surface.

2 While the glue is still wet, paint acrylic paint onto the glue. Do not mix the paint into the glue—just float a layer of paint on top of the glue.

3 The glue and paint will crackle when they dry, and you will be able to see your collage through the cracks.

TIPS

- Are you afraid of wrecking your collage background? You can add an isolation coat of clear polymer medium before you try these techniques. Let the polymer medium dry completely. If you don't like the outcome, you can wipe it off and you will have your original background. You may also spray with rubbing alcohol to remove the paint, gesso or faux encaustic.

- These techniques can be seen in greater detail in **Surface Treatment Workshop.**

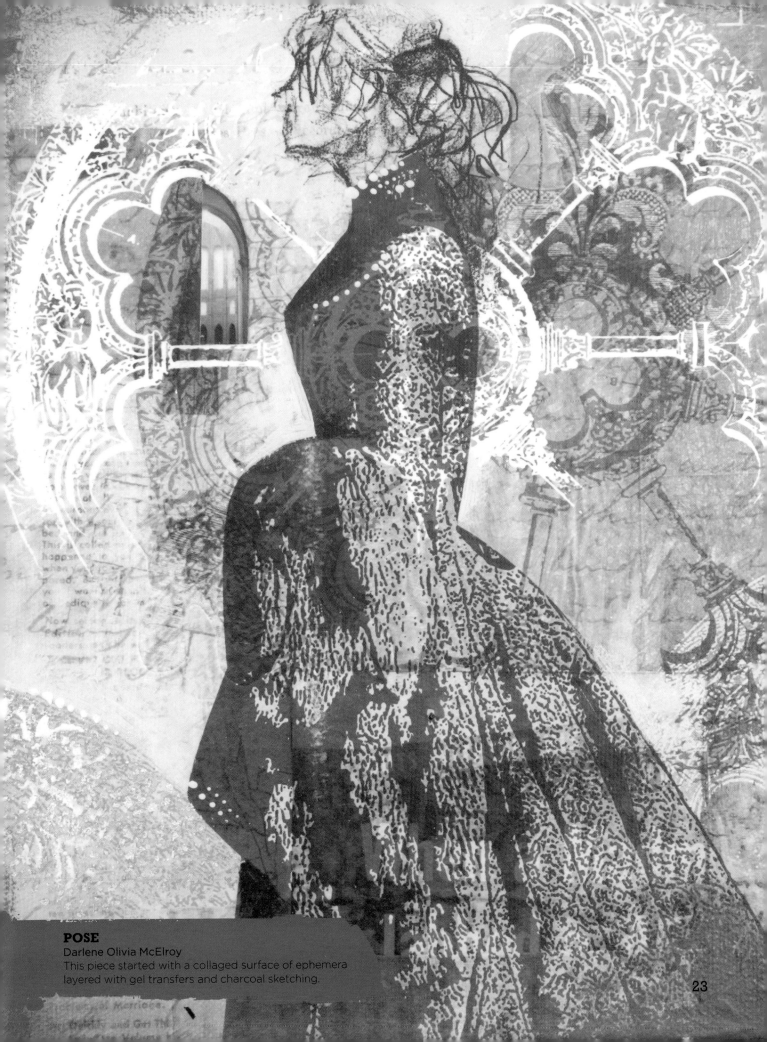

POSE
Darlene Olivia McElroy
This piece started with a collaged surface of ephemera
layered with gel transfers and charcoal sketching.

Chapter 2
COPY, SCANNING

Copy machines and scanners are two more tools in your arsenal, and they are so much fun. They allow you to layer, save the original, make an archival copy of a fragile paper or an unstable experiment, and even jump-start a new piece of art from part of an old one.

Consider the bed of a copier or scanner an art table where you can layer transparencies, stack objects or set fragile or perishable objects that you want to make copies of. Create your collage on the bed and then resize, change color and scale. Mix and match all or some of the many possible options copiers and scanners provide.

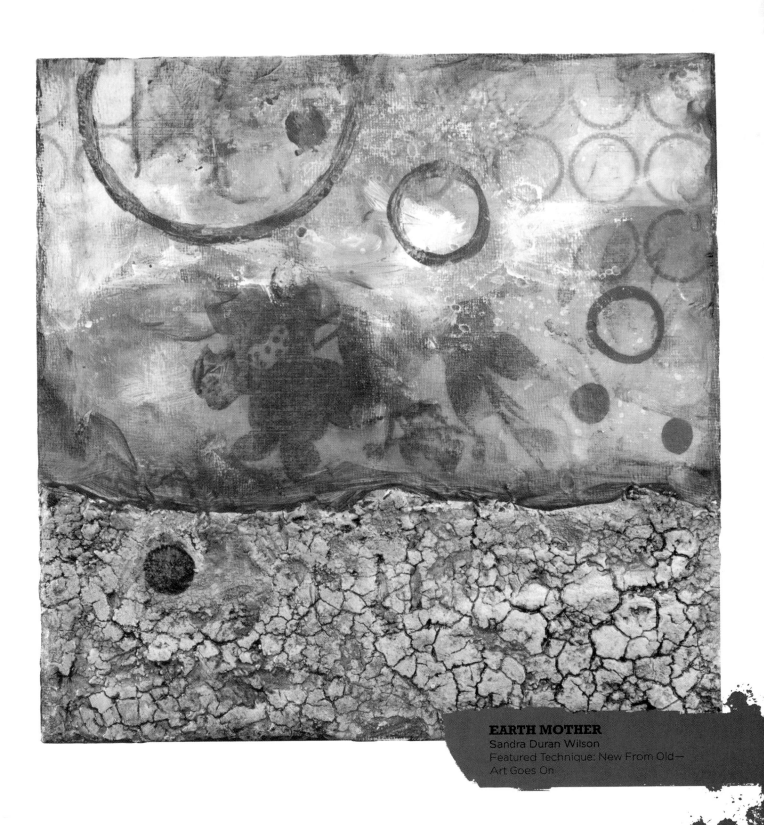

EARTH MOTHER
Sandra Duran Wilson
Featured Technique: New From Old—
Art Goes On

Group Fun

There is something magical about looking through layers. Picture in your mind what happens when you look into a shop window on a sunny day: You see not only what is in the window display but also your reflection and objects that are beyond the display. It's possible to create a similar layered look with your images without having to use a digital photo program.

TECHNIQUE ONE: JUST DO IT

Transfer your inkjet transparency image on top of an old watercolor painting, book or journal page or decorative paper. As long as the paper is absorbent you will be able to transfer your inkjet transparency image. To ensure that a watercolor painting or other paper you are transferring onto won't run, spray first with a workable fixative.

In demonstrating this technique, we have used multipurpose transparency transfers. One side of the transparency is intended for inkjet printing and the other is intended for laser printing. But you can print on either side with an inkjet printer (see step 3).

1 If you are using commercial paper that is coated (it will appear shiny), you need to lightly sand it to give it added tooth. Super glossy paper is not recommended for this technique.

2 Mist the sanded paper with water and rub the water into the paper. You want the paper to be saturated but you don't want the water to pool.

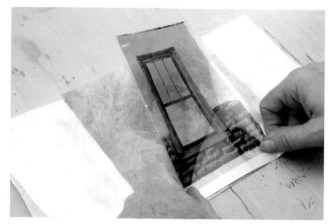

3 Smudge each side of your transparency to determine which side your image has been printed on. (If the rough side of the transparency is the side that has been printed on, you'll get a ghost transfer; if it is the glossy side, you'll get a total transfer.) Place your transparency printed side down on the paper.

4 Brayer the image from the transparency onto the paper. Use as much pressure as you can to transfer as much of the ink as you can, but if you see the transfer ink smearing, stop and wait a few moments for more water to be absorbed into the paper. Build up to strong pressure to fully transfer as much of the image as possible.

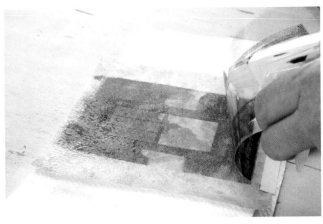

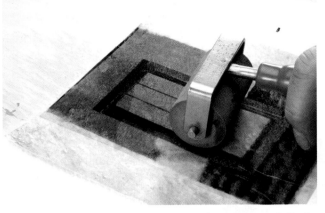

5 If you want more ink to transfer, lift the transparency and mist the paper with more water. If you are using a thin paper, like a rice paper, you can mist the back side of the paper without having to lift the transparency.

6 Continue to apply pressure until you are satisfied with the transfer of ink to paper.

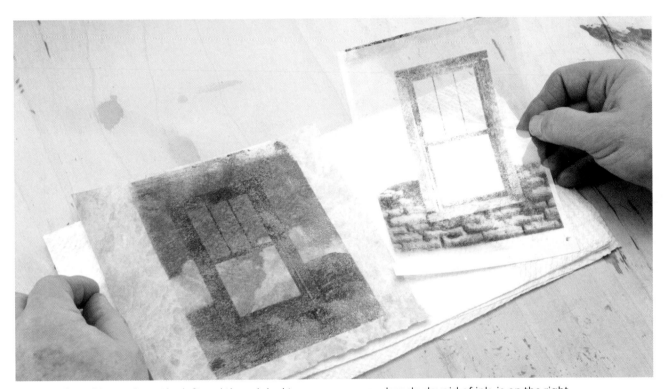

The transferred image is on the left and the original transparency, now largely devoid of ink, is on the right.

TECHNIQUE TWO: USE THE LEFTOVERS

1 Layer transparencies on the bed of the copier/scanner so they overlap each other.

2 If you are making your copy at a print shop you will need to create a digital file to put in your computer at home so you can print on an inkjet printer.

3 Print your layered image onto another inkjet transparency.

4 At this point you can transfer the image onto absorbent paper.

TECHNIQUE THREE: CLEAR TO ME

Transparency transfers are a fun way to get images onto bound books or journal pages. In this demonstration, we are transferring images to a painting.

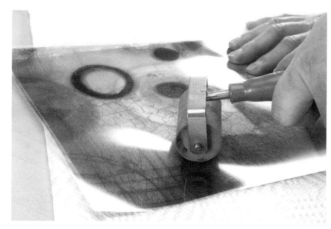

1 Use an inkjet printer to print onto transparency film. Mist your paper with water, put your transparency image face down and burnish until the image is transferred.

2 If you have used a transparency film for inkjets, you will have a ghost image left on the film. You can transfer this ghost image, too. (You can find more information on transparency transfers in our first book, **Image Transfer Workshop**.)

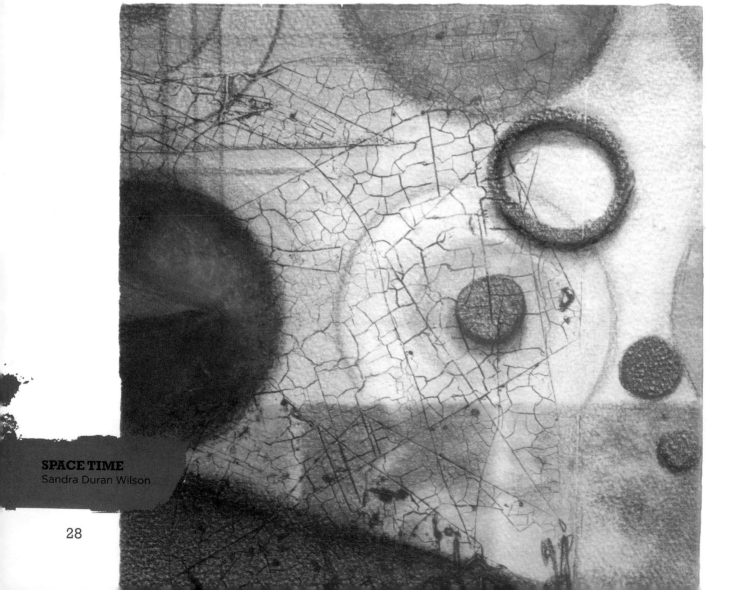

SPACE TIME
Sandra Duran Wilson

New From Old

Waste not, want not. Make new art from old by reusing what you were going to throw away. Bet by now we have you afraid to throw away anything!

This technique can be done using either a copy machine or scanner.

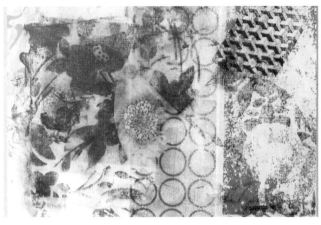

1 This is a fun way to use your leftover inkjet transparency film. Take several leftover transparencies, cut them up and layer them together on the bed of the copier/scanner so they overlap each other. You may want to add an interesting paper on top of them. The paper becomes a background when the whole grouping is printed.

2 Print out your new image using a laser or toner printer. Laser/toner copies are not water soluble; they are set with heat and this enables you to make a gel transfer that won't smear.

3 At this point you can use your newly printed image as collage paper, use it as a transfer or continue altering it as desired.

TIPS

- You may get some smearing when using an inkjet printer to make a gel transfer. If you only have access to an inkjet printer and you absolutely have to try this right now, spray the printout first with a workable fixative. You may have to spray several times for best results. (Visit createmixedmedia.com/mixed-media-revolution for more on gel transfers.)

- If you don't apply the gel on perfectly, your transfer can be more random—which isn't necessarily a bad thing!

- Your transfer should be moist—not wet. If it is wet, you could end up with unwanted wrinkles. But, again, those wrinkles could add a bit more visual interest, too.

For a **full photographic step-by-step demonstration of a gel transfer**, scan this QR code with your smartphone or visit createmixedmedia.com/mixed-media-revolution.

Dreamy

The paper backing from painted or printed fusible web has a beautiful dreamy look. We like to leverage this and, of course, scan it or copy it, and then use it again and again. No one will guess what you have used unless, of course, they read this book.

TECHNIQUE ONE: UNDER WATER

In **Image Transfer Workshop** we showed you the awesome capabilities of fusible web. This demo offers a way to use the backing paper that comes with fusible web. You keep the paper on the web when you are painting or stamping, or you can use an inkjet printer to print on to it. (Never put fusible web in a laser printer!) After you have printed or painted onto your fusible web, use the backing paper as a collage element. You'll need to spray it with a workable fixative to keep the ink from running. Use it without spraying to achieve a watery look.

Above is a piece of fusible web with its backing paper attached. The web has been painted with different types of paint. The photo in the center shows the webbing separated from its backing paper. The photo to the right shows a photocopy of the backing paper.

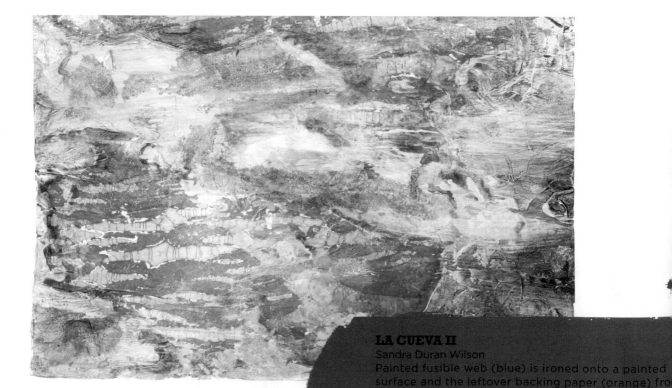

LA CUEVA II
Sandra Duran Wilson
Painted fusible web (blue) is ironed onto a painted surface and the leftover backing paper (orange) from another piece of web is glued onto the surface.

30

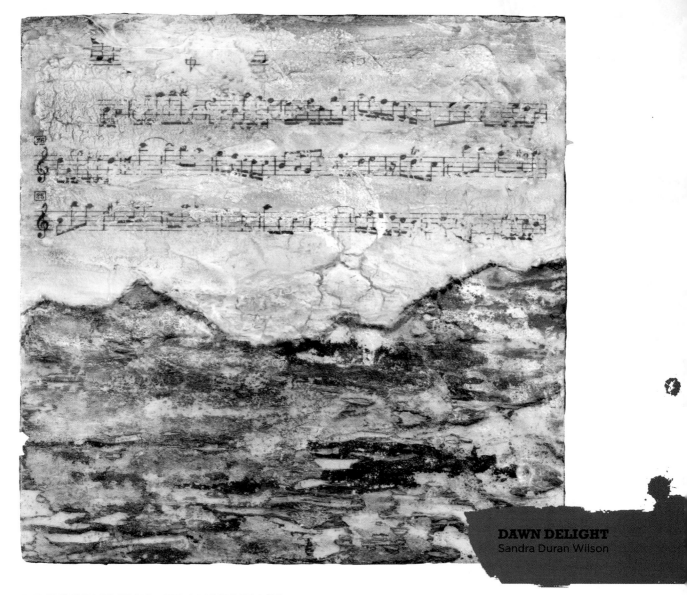

DAWN DELIGHT
Sandra Duran Wilson

TECHNIQUE TWO: TRANSFORM IT

1 Make a laser or toner copy of the fusible web backing paper (never put fusible web into a laser printer). You can use this copy for a gel transfer.

2 Put some soft gel gloss onto the surface you are going to transfer to. While the gel is wet, place the image face down and rub all over to assure adequate adhesion. Be careful not to get gel on the back of the transfer.

3 Allow gel to dry overnight. Then remove the paper backing by misting with water and rubbing off the paper. A piece of brown craft paper is especially helpful in removing the last bits of the paper backing.

TIP
If you still have a bit of paper residue on your transfer, use a damp brush with polymer medium to coat the surface. When dry, this will make the residue more transparent.

For a **full photographic step-by-step demonstration of a gel transfer**, scan this QR code with your smartphone or visit createmixedmedia.com/mixed-media-revolution.

▌Do a Restart

Imagine this: You are in the middle of creating a painting and you love, love, love the background or a particular portion of it. You don't know whether to stop or continue painting. We say before going any further, scan, copy or photograph your work so you can use it later in another piece. Then you can finish the painting and have two pieces (or more!) for the effort of one.

TECHNIQUE ONE: JUST A LITTLE

Whether the colors in an area of the background, the looseness of the strokes or a portion of a pulled paper transfer—if you love it, scan, copy or photograph it for future use. This way you can enlarge it and change the colors, too!

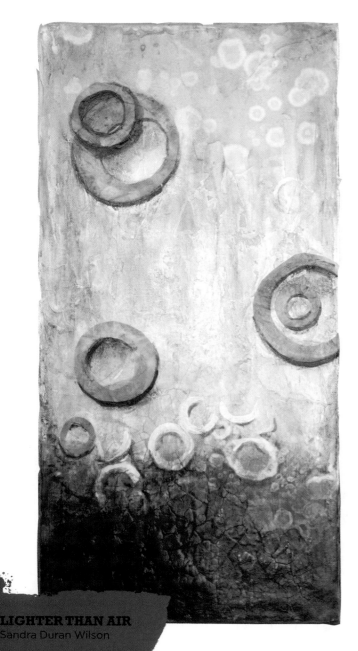

This photo above shows a fabulous underpainting texture. It is an alcohol resist done with two different colors. The image was scanned and slightly enlarged. It was then used as a gel transfer onto a canvas. Paint, crackle medium and collage were added to finish the new painting (on the left).

LIGHTER THAN AIR
Sandra Duran Wilson

TECHNIQUE TWO: I WANT IT ALL

A friend was just starting a quintet painting and her strokes and colors were yummy and loose. We knew she would get tighter and cover up much of that looseness so we convinced her to take a photo of the whole piece to give her a starting point for a future painting.

Here are a few examples of backgrounds that have been scanned and saved. They can then be finished, cut up, transferred or otherwise morphed into new paintings. Once scanned, the backgrounds may be reused and finished differently multiple times.

A small sample is saved and enlarged.

An assortment of ghost transparencies can be rearranged.

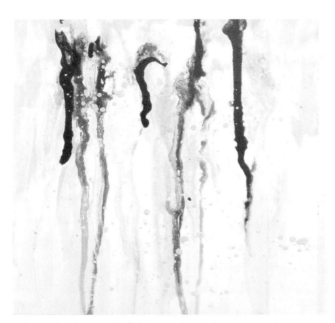

A loose background of drips and runs is preserved.

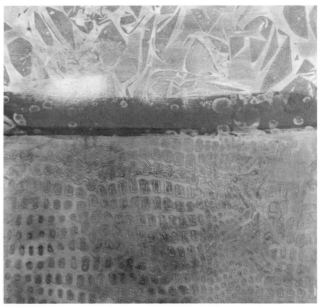

Textures, layers and color combinations are preserved.

Paint and Scan

If you are as messy as we are, you are continually blotting your painting and wiping your brushes and paint spills. Keep a paper towel next to your water bucket to clean your brushes and when the towel becomes loaded with color, scan it and use it in your art. In addition to making a unique art element, you will have a clean studio. Before you scan, try embellishing the towel with the following ideas.

You can also stamp the excess paint from a stencil or stamp onto a paper towel or other surface for more visual interest.

Stamped towel

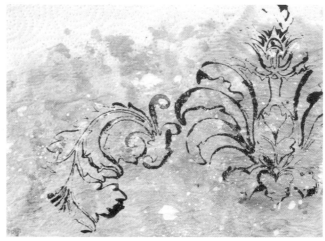

Stenciled towel

Crumpled towel

MORE IDEAS

- If the paint is still wet, spray or sprinkle some water on it to soften the colors.

- Crumple a paper towel and use it to blot your wet paint for texture, spread out the paper towel and let it dry for a cool pattern to scan.

- Make a laser/toner copy of your paper towel and use it as a gel transfer.

- Cut the paper towel into shapes for a collage; you can also resize it on a copier and alter colors with a photo-editing program.

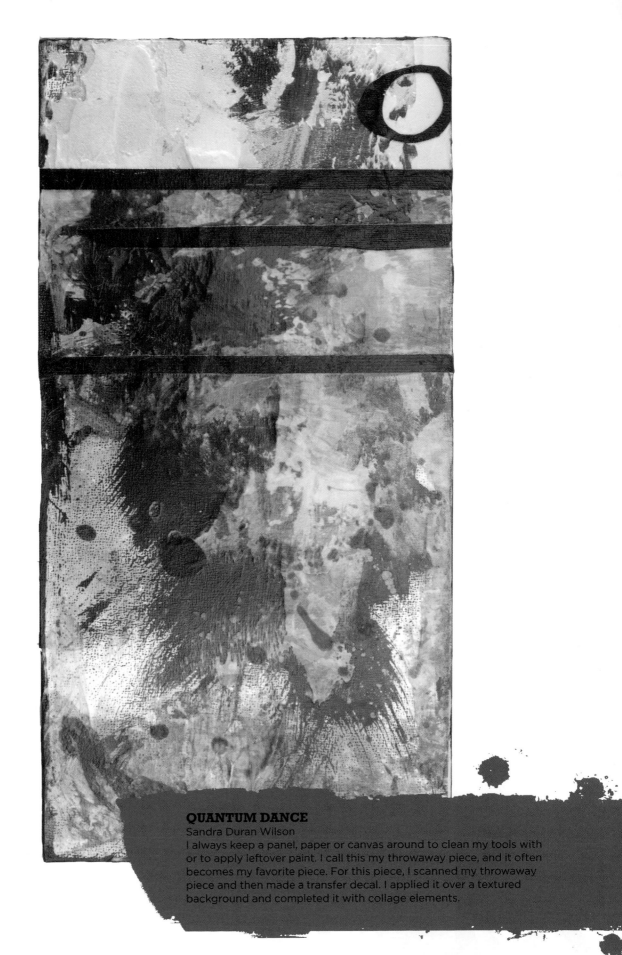

QUANTUM DANCE
Sandra Duran Wilson
I always keep a panel, paper or canvas around to clean my tools with or to apply leftover paint. I call this my throwaway piece, and it often becomes my favorite piece. For this piece, I scanned my throwaway piece and then made a transfer decal. I applied it over a textured background and completed it with collage elements.

Save for Another Day

Sometimes you find an object that catches your fancy. It could have a beautiful patina or a rusty tidbit, or perhaps it is a textured Tyvek remnant, a wall with layered pulled posters, the bubbles in your sink, the cantaloupe in the fridge or something else entirely. You get the idea. Photograph, copy or scan the object of your inspiration. You may want to make several copies of different scale to have on hand. They can all go in your art arsenal of images to be used now or sometime in the future.

Corn Husk Print

Cantaloupe Print

Mossy Stone

Rust

Paint Splatter

Eggshells

Read All About It

Words are wonderful things. They have meaning, they have form and they have beautiful shape—especially words from languages we don't speak. Think of all the wonderful ephemera out there: old postcards, vintage magazines, ledger pages, books, pattern papers ... the possibilities are endless.

TECHNIQUE ONE: LEFTOVER LAYERS

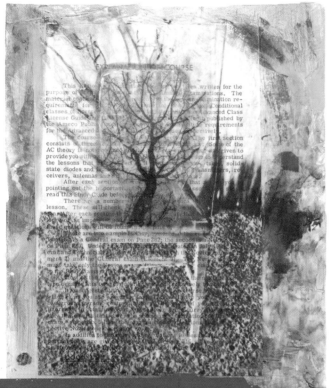

Layer a leftover transparency over a book or ledger page. You can then scan it, print it and use it as a transfer or collage paper.

SEAT OF KNOWLEDGE
Sandra Duran Wilson
In this finished piece, I glued the transparency (to which I added a transfer of an image of a tree) onto another substrate using a spray adhesive.

If you think you might want to use it in a gel transfer, you will need to flip the image before you print. Otherwise the text will print backwards (which can be a nice effect, too).

TECHNIQUE TWO: PRINT AND GLUE IT

Cut your ledger, magazine or book page to fit your printer carriage—or tape them carefully to a carrier paper—and print an image onto it. If you have an inkjet printer, make sure you spray your print with a workable fixative before using it as a collage element.

TECHNIQUE THREE: SCAN IT, PRINT IT, TRANSFER IT

There are so many ways to transfer a copy of your ephemera. The beauty of most transfers is their transparency. Remember that anything that looks white in printing is actually absent of color, so when you use this in a transfer, you will see the underlying color. This leads us to the next chapter on creating layers.

Chapter 3
CREATE LAYERS

Have you ever looked at a painting and wondered how the artist created the textures or layers? Have you looked at a piece and been able to identify all the techniques the artist used? Usually the artwork that has the harder-to-identify layers is more intriguing than a less complex work. Combining techniques and layers creates mystery. You can challenge your viewers and keep them guessing by building multiple layers, adding isolation coats between layers, creating ghostly collages and glazing. Try these tricks to add depth and mystery to your work.

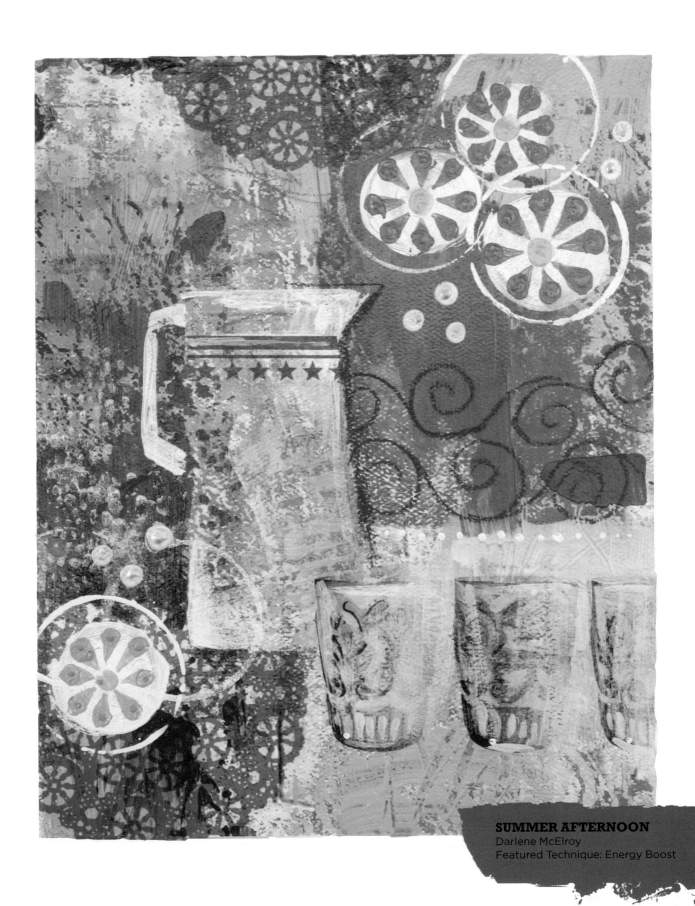

SUMMER AFTERNOON
Darlene McElroy
Featured Technique: Energy Boost

Make a Sandwich

Doesn't playing hard make you hungry—for more art, of course? Make yourself a sandwich. And what is a sandwich but something put between two layers?

TECHNIQUE ONE: ENVELOPE IT

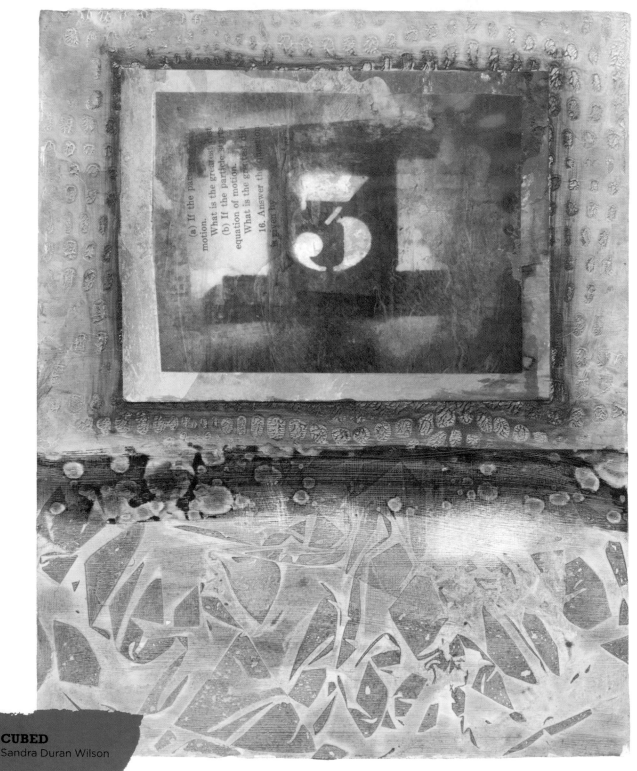

CUBED
Sandra Duran Wilson

Take transparency film leftovers and painted book pages and sandwich some leftover collage papers, thread, gold leaf crumbles, a ribbon or whatever tickles you in between them. Seal with spray adhesive or repositionable sheet adhesive. Or seal the edges with staples or ventilation tape for a more industrial look.

1 Take two pieces of fusible web that perhaps you had painted or printed on and add cut-up paper, gold leaf crumbles, cut-up words or numbers—whatever inspires you—and place between the two pieces of fusible web.

2 Put the layers between pieces of parchment paper and heat with a dry iron to fuse.

You may apply this piece directly to your work, or for an even more diffused look, scan it or copy it and use as a transfer or collage.

Multiple Personality

Layer. layer and then add more layers. This is our mantra along with reuse, reuse and reuse. When you use your stencil, the residue paint or medium that is left transforms your stencil into a stamp. In addition to that, the paper or plastic that protects your work table and is slopped with paint is a potential collage or transfer element. Keep layering to get interesting results.

TECHNIQUE ONE: IN DISGUISE: CRAZY EASY TRANSFER WITH POLYPROPYLENE PLASTIC

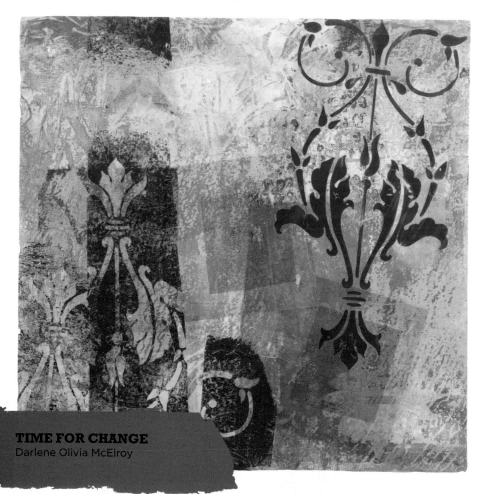

TIME FOR CHANGE
Darlene Olivia McElroy

1 Make a multiple personality composition: Use your stencil as a stamp and press it onto a piece of polypropylene plastic, plastic bag or gampi paper.

2 Let it dry and then layer more stencils and stamps onto the surface, overlapping different mediums, paints, etc. After a while you will have an interesting piece that you can then transfer to another painting.

3 Apply soft gel gloss or polymer medium (because of its rough texture, canvas needs the gel) to the area of your painting or collage to which you wish to apply your transfer.

4 While the gel is still wet, place the transfer paint side down and rub or press with a brayer to ensure good adhesion.

5 Let dry completely. Depending on the surface you are transferring onto, this could take thirty minutes or three days.

6 Carefully pull the plastic off and your collaged is affixed.

TECHNIQUE TWO: IN DISGUISE: GAMPI PAPER COLLAGE

1 Apply soft gel over a stencil—this will ensure that the paint will adhere well and look crisp.

2 Apply paint over the wet soft gel.

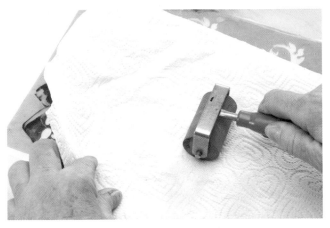

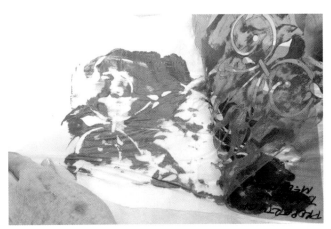

3 Stamp the paint that is leftover on the stencil onto a piece of gampi paper. Brayer over the stencil to transfer as much of the paint as possible as neatly as possible.

4 Peel the stencil from the gampi paper to reveal the transfer.

TECHNIQUE THREE: IN DISGUISE: IRRESISTIBLY ABSORBED

After doing the technique above, you can also use the stencil with the leftover paint on it as a stamp. Apply it directly onto a substrate.

Once the paint has dried, repeat the stamping process using a gloss gel. Overlap the applications.

Allow the gel to dry. This process can be repeated using other gels, paints and pastes to add as many layers as you'd like.

If you use both gels and pastes without paint added, you can glaze over the layers when they are dry. Different types of gels and pastes will absorb the glaze differently and the result will be varying hues of your paint color. Gloss, for example, will resist, while pastes will absorb.

Transparently Collaged

Oh, for a pair of rose-colored glasses to make the world appear more saturated. A subtle hint of color, the glimpse of an image or a slight shift in hue: These little things can make your piece of art sing. Our gift to you is your own pair of rose-colored glasses.

TECHNIQUE ONE: GHOST IT

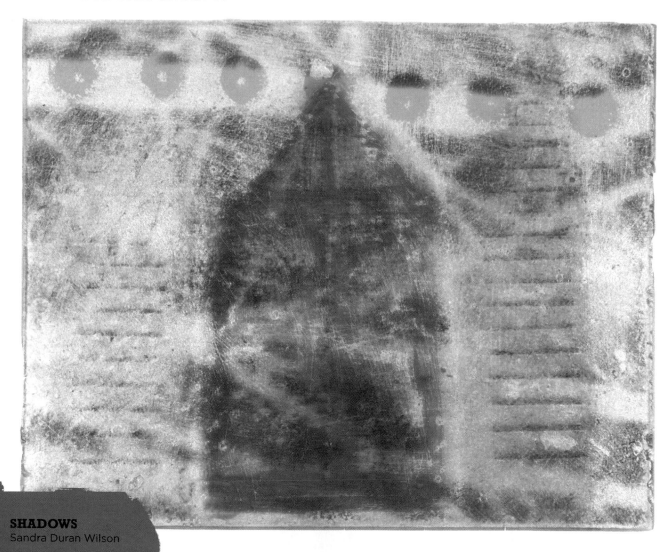

SHADOWS
Sandra Duran Wilson

For a **full photographic step-by-step demonstration on making and using waterslide decals**, scan this QR code with your smartphone or visit createmixedmedia. com/mixed-media-revolution.

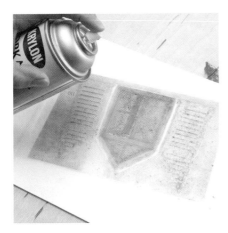 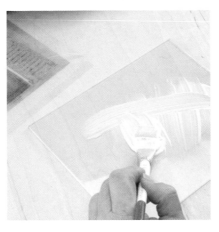 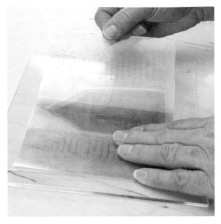

1 Spray a ghost transparency (an inkjet transparency that you've already used as a transfer) with a workable fixative.

2 Add a glaze to a piece of Plexiglas.

3 Adhere your transparency to the Plexiglas with either gel or adhesive spray or film.

 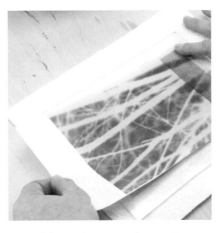

4 Seal the transparency by brushing a layer of gel over the top of it.

5 Add another transfer to the back side of the Plexi. Here I used a waterslide decal.

6 Brush over the surface of this transfer to remove any bubbles.

 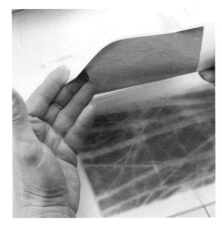 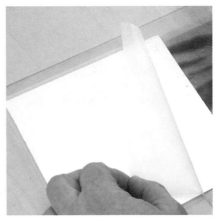

7 To add metallic leaf to the back of the piece, first spray the piece with adhesive.

8 Lay the leaf over the fixative and press to adhere.

9 Peel the backing paper off the leaf.

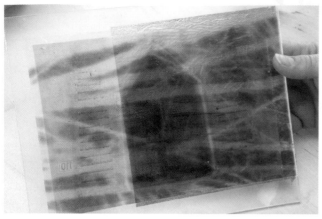

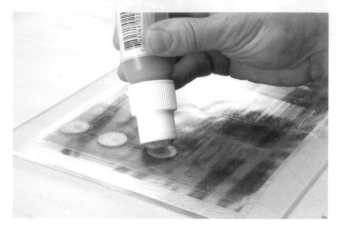

10 Notice the difference between the right side and the left side (which is not leafed).

11 For added texture, stamp some paint on the front of the piece. You can stamp paint on the back of the piece but you have to do it before the leaf is added.

More Ideas

- You could substitute any number of transfer techniques in this project. The paper transparency transfer featured in **Image Transfer Workshop** would be a particularly good alternative.

- For covering over the transparencies, we used gloss gel. If you use gloss gel, lightly sand the Plexi first to ensure better adhesion.

- If you'd like your image to appear even more ghostly or diffused, be sure to use matte gel instead of a gloss gel.

- Be sure to save those little bits and pieces and edges left over from making a waterslide decal. You can use them for mini transfers. Writing and doodling on these small pieces is also a great way to use them up.

TECHNIQUE TWO: SEAL IT UP

Take two pieces of mica and put feathers, dried grasses or other found texture between them. You can use aluminum ventilation tape to seal the edges, or you can solder the edges with copper tape, solder and a soldering iron. Add jump rings if you want to hang the finished piece.

FOOTLOOSE IN FRANCE
Sandra Duran Wilson

Energy Boost

Get your art all worked up. No need for aerobic classes, special clothes or music with a strong beat. This is the art-technique version of an energy boost that will give your artwork tone. Let's stretch those art muscles now.

TECHNIQUE ONE: TRY THEM ALL

So many wonderful transfer techniques layer well. Try a paint technique or two placed between the layered transfers, or try multiple surface techniques for that depth and change of energy.

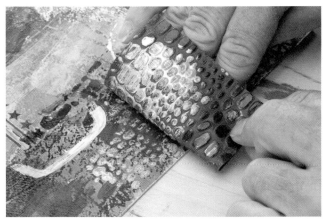

Add an interesting paint technique. Here we used a textured paper as a stamp.

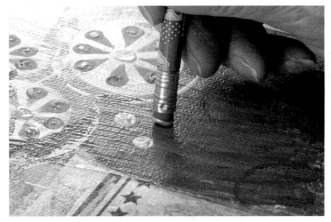

Layer on additional paint techniques. Here we used a pencil eraser stamps pretty polka dots.

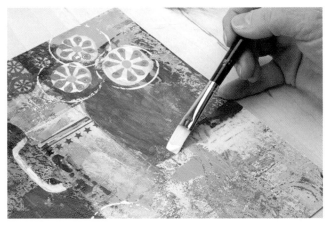

Apply clear gesso or another absorbent ground to any areas of the surface that you may want to draw on.

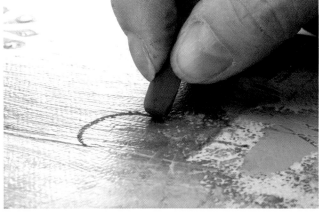

Add hand-drawn decorative elements as you desire. A Conte crayon adds a swirl pattern, which we sprayed with a workable fixative.

TECHNIQUE TWO: MIX IT UP

If you already have a wonderfully layered background, you may want to add a stencil image on top. The mix of veiled layers against a flat image creates a wonderful contrast, like sweet and sour, smooth and rough, delicate and tough. The unexpected contrast is so perfect.

Draw On It

Oh no! You want to draw on top of your painting but it's too glossy from all the acrylics. Not a problem! This trick is great for painting on surfaces that are difficult for paint to adhere to, like metal leaf, plastic and glass.

TECHNIQUE ONE: CLEAR IT

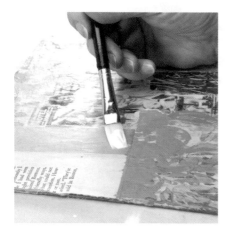 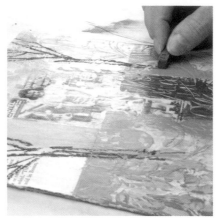 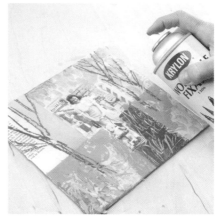

1 Paint a very thin layer of clear gesso or absorbent ground on your surface. Wipe off any extra and let dry.

2 This will give your surface enough tooth to be drawn on with pastels, pencils or charcoal.

3 Spray with a workable fixative to set your drawing before painting or putting on a varnish.

TECHNIQUE TWO: JUST DO IT

China markers (or wax pencils) will draw on most surfaces. They comes in four basic colors, but because they are wax, they will resist any acrylic that you put on top of them. Stabilo pencils and Sharpie paint pens are a better solution when you want to add acrylic layers on top. They come in a huge assortment of colors.

TECHNIQUE THREE: TRACE IT

Paint a very thin layer of clear gesso or absorbent ground on clear polypropylene plastic. This will give your surface enough tooth to allow you to draw on it with pastels, pencils or charcoal. Place an image underneath. Draw on the plastic. Use a workable fixative to set it. You may also draw directly onto the plastic using the Sharpie paint pens or Stabilo pencils without having to use clear gesso. You can now do a Crazy Easy Transfer to place your image anywhere on your painting or page.

For more information on the **Crazy Easy Transfer technique** scan this QR code with your smartphone, or visit createmixedmedia.com/mixed-media-revolution.

Two-Way Street

Painting on Mylar and transparencies is double the fun because you have two sides to work with! You create instant depth by painting on both the front and back.

TECHNIQUE ONE: PAINT AND PRINT

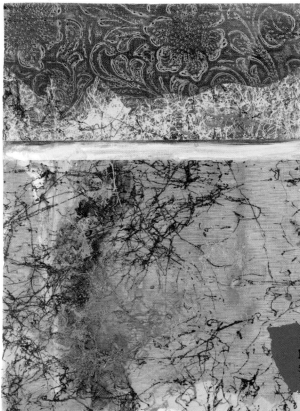

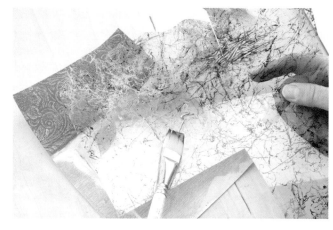

Print a laser/toner image onto transparency film. Paint on both sides, letting each side dry before painting the reverse. Cut up and use it in a collage or glue it to your surface of choice.

PATHWAYS
Sandra Duran Wilson

TECHNIQUE TWO: GIVE IT DEPTH

You can paint on Mylar with acrylic—lightly sand it first with a fine-grit sandpaper or use a clear gesso before painting to assure adhesion. You can paint (like I did here), collage, transfer, apply gold leaf and/or stamp on both sides. Flip it back and forth to see which side you like best. Adhere to a painted background for instant depth (my background is painted and collaged). If you use a matte medium to adhere the Mylar to the background, you get a waxy finish.

MORPH IT

Roadblocks can be frustrating or they can lead you on a new adventure. Don't let them block your artistic journey. When you encounter roadblocks or detours, take on a sense of adventure and let your creativity wander down an unexplored path. Your art may find its way to a higher level. Sometimes it takes so little for that leap to happen. You can infuse new energy and instill presence in your piece by switching to an alternative surface. Or try simply turning your canvas, adding on elements, cutting the whole thing up or passing it on.

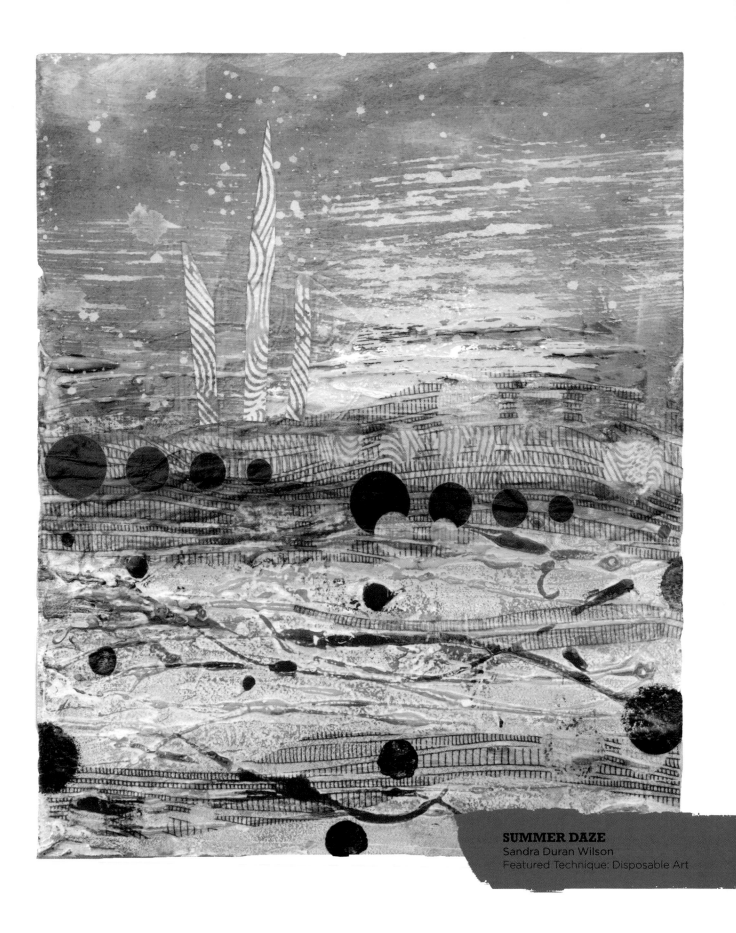

SUMMER DAZE
Sandra Duran Wilson
Featured Technique: Disposable Art

Changing Identity

You love what you are doing, but sometimes you want to try on something new and different. Maybe you want to experiment with an edgier look, or perhaps you want to create a series that is tied together by some WOW factor. Well, then, let's talk surfaces. If you are a regular gallery visitor, you have seen some of the cool surfaces artists are using as foundations for their art, such as metal leaf, metal, Plexiglas, bamboo, mica and glass. Take your art for a test drive on a new alternative surface using a waterslide decal. You can always go back in and paint on top of the decal. For fun, try some of the surfaces listed in the examples.

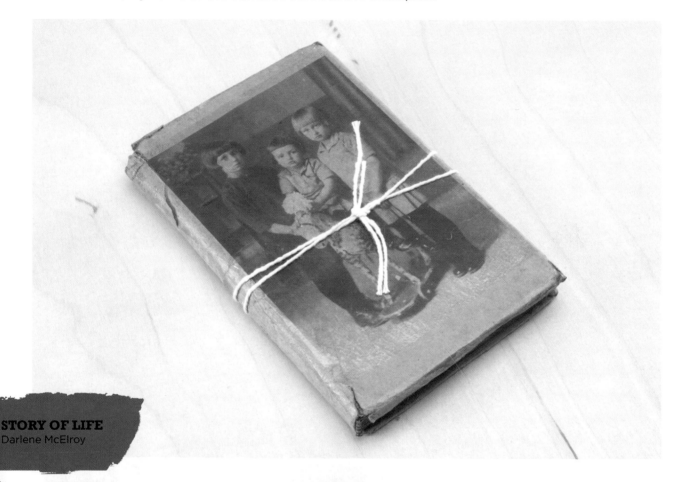

STORY OF LIFE
Darlene McElroy

Fabric

Metal

Metal Leaf

More Surfaces to Try:

- Plexiglas
- Metal Leaf
- Aluminum Foil
- Metal
- Glass
- Wood
- Fabric
- Mirror
- Mica
- Clayboard

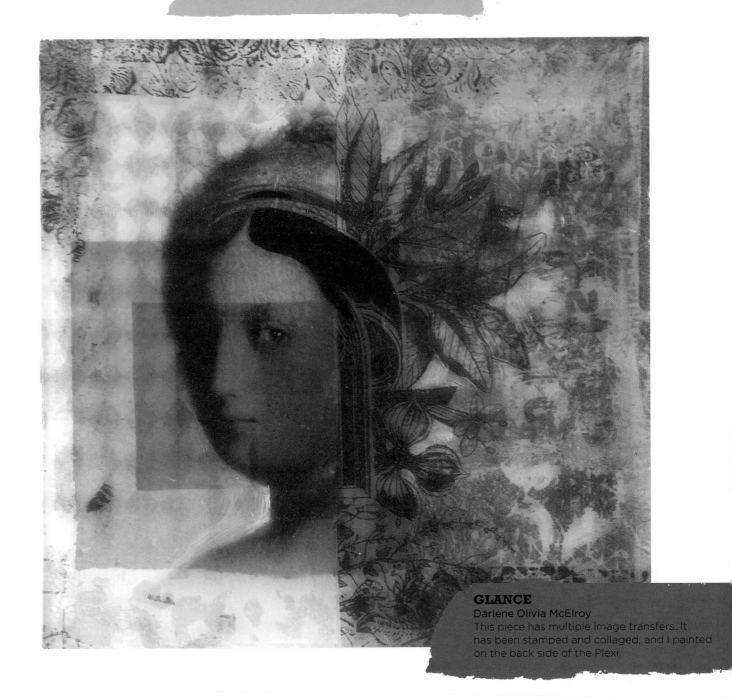

GLANCE
Darlene Olivia McElroy
This piece has multiple image transfers. It has been stamped and collaged, and I painted on the back side of the Plexi.

For more information on **making and using waterslide decals**, scan this QR code with your smartphone or visit createmixedmedia.com/mixed-media-revolution.

Be an Architect

When the housing market isn't great, people reinvent their homes by remodeling or adding on. Artists can do the same thing with their art: Build on it to make it bigger and better. Some ideas? Add architectural elements in wood or metal, bolt wood panels or canvases together, add dimensional objects or boxes to it and see what evolves. "Adding on" gives your piece of work more presence.

Finished panels waiting to be assembled.

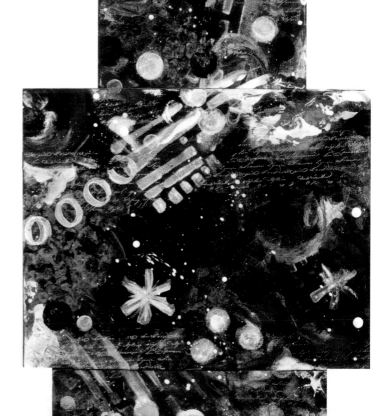

THE NORTHERN LIGHTS GO SOUTH
Sandra Duran Wilson
The panels were drilled and nuts and bolts were attached to hold them together. The painting is wired so the panels hang as one painting.

Block in the background before adding your image and desired transferred and collaged elements.

Wood elements can be added by both gluing and screwing in braces for added security.

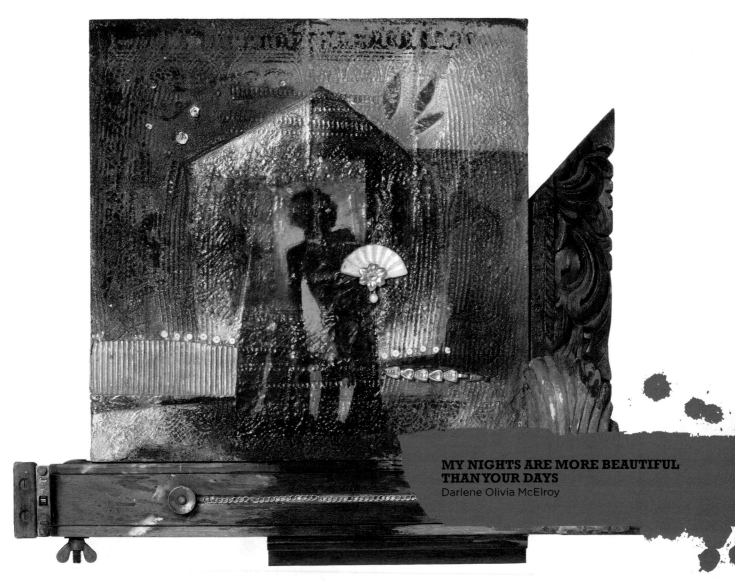

MY NIGHTS ARE MORE BEAUTIFUL THAN YOUR DAYS
Darlene Olivia McElroy

All Shook Up

When I was a kid, I loved standing on my head and looking at the world upside down. Even as an adult doing so gives me a new perspective on things. You don't have to stand on your head to try this trick. Just turn your art upside down.

When you look at a piece and you know something is off or just not working but you just don't know what it needs, turn it upside down. If it is a figurative or realistic painting, the error will become clear. If it is an abstract piece that needs some variety, energy or oomph, this trick will also work. When you have been working on a piece for a while, you can easily lose your perspective. Try rotating the piece at different stages of development. You will also be better able to evaluate your composition.

For example, one day my husband said to me that the painting I was working on looked great but it was upside down. I had been looking at it for so long that I just couldn't see what he meant. I turned it over and spent a few days looking at it and of course I could see that he was right. He's a talented creative with a good eye.

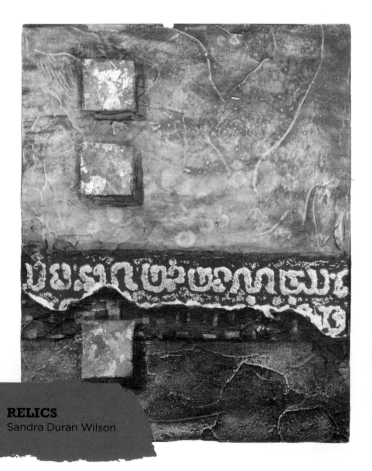

RELICS
Sandra Duran Wilson

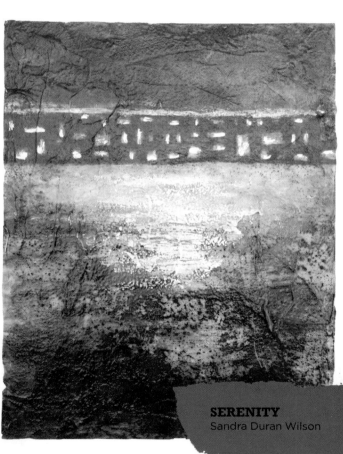

SERENITY
Sandra Duran Wilson

These two paintings feature the same background but are finished in different orientations.

Disposable Art

This is one of the best tips we can give you: Keep a canvas, board or watercolor paper around your studio and consider it your throwaway piece. When you have way too much paint left over and you won't be able to save it, don't throw it away and never put it down your sink. Instead, paint it on your throwaway piece. Perhaps you have lots of paint left over on your stencil. Clean it off on your throwaway piece. Stamps inked up? Stamp the excess paint on your throwaway piece. Left over mediums or gels? Throwaway piece. Before you know it you have a great start for another painting without having to think about it.

Because you are not overly attached to it and are not analyzing every stroke, you could end up with the beginning of a masterpiece. This is a great practice to help loosen up your style.

Using up leftover paint adds layers to a throwaway piece.

Applying leftover gel to a throwaway piece adds texture.

More Ideas

- Use vegetable skins or the bottom of cut celery to stamp interesting texture onto your art.

- Use discarded coffee grounds as a stain to age paper.

- Kitchen sponges can find a second life in the studio before they are tossed for good.

- Used dryer sheets make great collage papers.

- Styrofoam containers make great stamps, and don't get us started on packing materials!

Forget About It

Are you frustrated because a portion of your art just isn't working? Instead of hiding it in the dark recesses of your closet, try one of these options. These techniques can be used to fix just about every problem you may be having with a difficult painting.

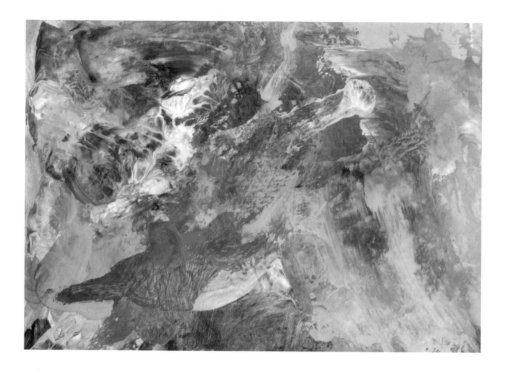

TECHNIQUE ONE: ERASE IT

Did you know that alcohol acts like an eraser even on dried acrylic? Yep, it's a handy thing to know.

Spray rubbing alcohol directly onto the surface and let it sit for a few minutes, then rub off with a paper towel. Repeat as needed. For more control put alcohol on a paper towel, and then rub in the desired area.

TECHNIQUE TWO: SAND IT BACK

Use sandpaper to create a mysterious look.

This should be done on dried and cured acrylic, otherwise it gets gummy. Try various grits.

TECHNIQUE THREE: PAINT MORE

Paint over a part of the painting you don't like.

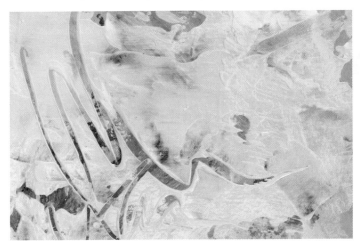

Use heavy-bodied paint or a heavy gel mixed with your desired color. Load up your palette knife and drag it lightly over the surface. You will get broken coverage and the underlying color will peek through.

TECHNIQUE FOUR: COVER IT UP

If all else fails, glue something on top of it.

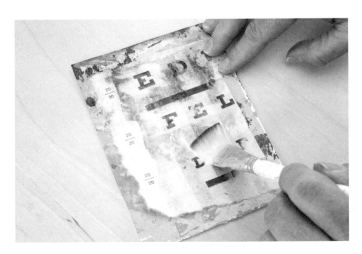

A thin rice paper was glued on top with polymer medium. Portions of the background show through, but the letters unify the piece.

TECHNIQUE FIVE: CREATE A QUIET SPACE

A little bit of gesso goes a long way.

When you need to introduce a light color onto an otherwise dark surface, you will need to add white first. Select an area and paint with gesso or light modeling paste. Let dry and add a light color over the gesso or paste.

A New Weave

I know that not every painting is the masterpiece I was hoping it would be. I may put a less-than-favorite piece away for another day or I may find myself looking at it and deciding that I like parts of it but not the whole of it. That's when I take scissors in hand.

TECHNIQUE ONE: WEAVE IT

You can do this using several different pieces.

1 Cut one piece of art into horizontal strips.

2 Cut another piece of art into vertical strips.

3 Weave together.

4 Glue the weaving to your background with polymer or soft gel.

5 Press with a brayer.

6 Let dry.

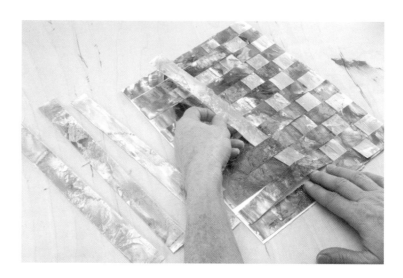

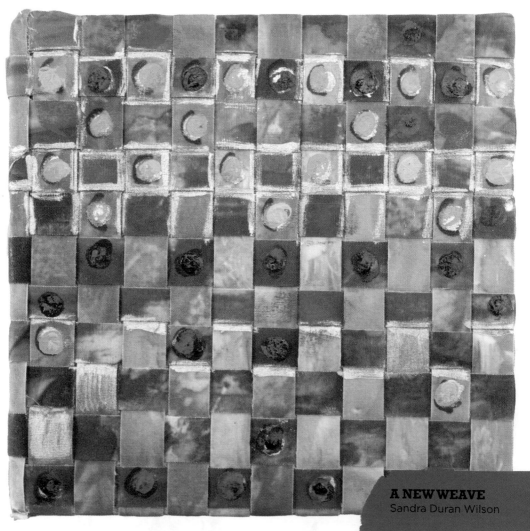

A NEW WEAVE
Sandra Duran Wilson

TECHNIQUE TWO: ALL MIXED UP

For this technique you need only one piece of art.

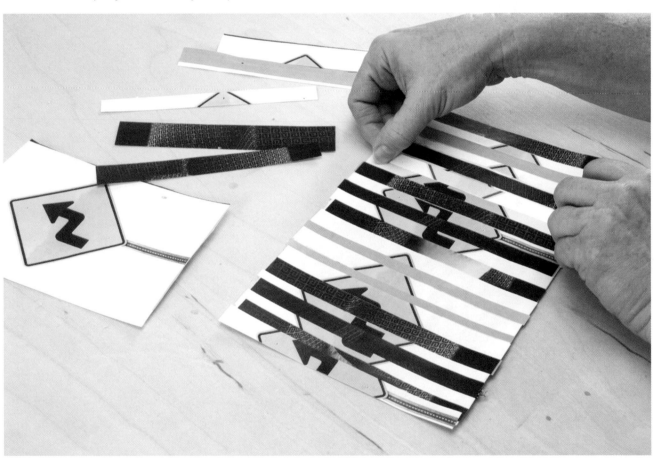

1 Cut the work into strips or sections, vertical or horizontal.

2 Rearrange the strips in a different order than the original or break them up by inserting space between them.

3 Glue them to your background with polymer soft gel.

4 Press with a brayer.

5 Let dry.

Pass It On

We both belong to a critique group. Participation is not only great fun but very helpful in growing as an artist. Six of us are in the group, and each of us has a different style and uses different media. We use oil, acrylic and collage. We have passed around a painting that each of us is contributing to and it sparks lots of new ideas. Try this with a friend or two, or just pass it on.

TECHNIQUE: ROUND ROBIN

Get together a group of artist friends and have each start with a painting that isn't quite working. Pass each piece around the group with each person adding something to the piece (this is commonly known as a round robin). Yes, it does require giving up control of your original concept. If you all participate in this round robin, with each putting in a piece of work, everyone comes out with something unique. You only need a couple of rules:

> Begin with the acrylic painters and collage artists and finish with the oil painters.
>
> Each artist's work must appear somewhere in the finished piece.
>
> No one covers the whole piece.
>
> You can do this with a painting, collage or sculpture or any combination of the three.

More Ideas

- Pass It On: Do you know an art student who's low on supplies? Pass on your used art supplies, old canvases and paper, and plant the seeds for a budding new artist.

- Donate It: A wonderful fund-raising event in Santa Fe encouraged artists and others to donate new and used art supplies, paintings and other miscellaneous items. It was the best of secondhand sales and a great social event as well.

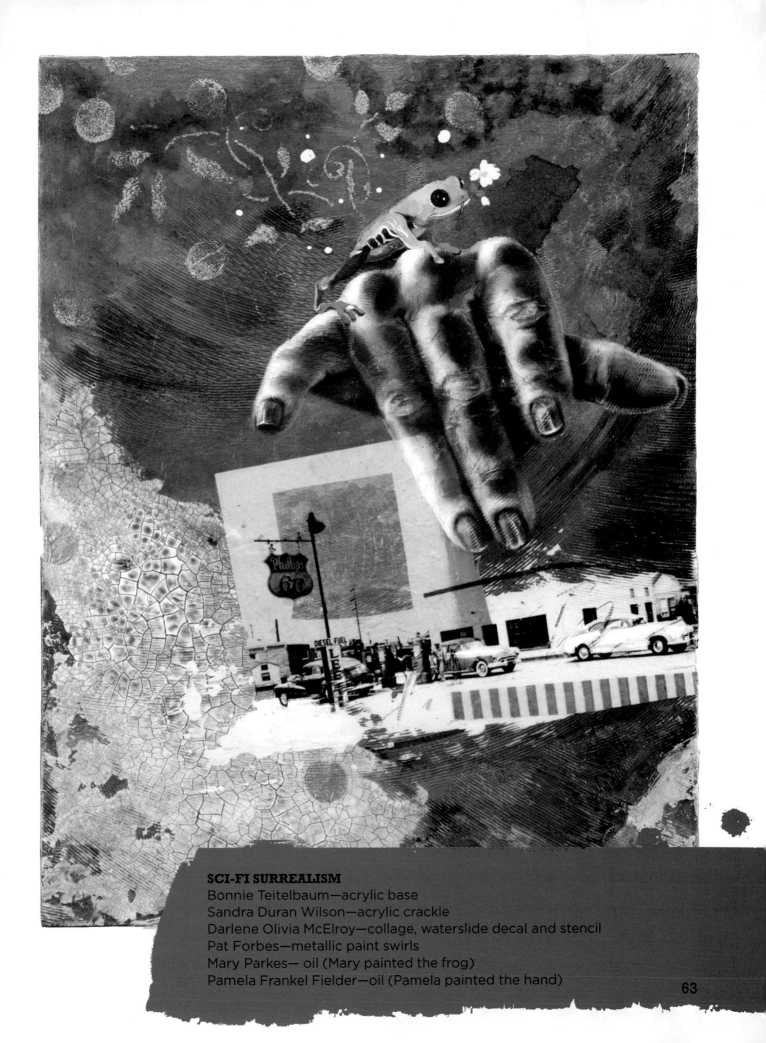

SCI-FI SURREALISM
Bonnie Teitelbaum—acrylic base
Sandra Duran Wilson—acrylic crackle
Darlene Olivia McElroy—collage, waterslide decal and stencil
Pat Forbes—metallic paint swirls
Mary Parkes— oil (Mary painted the frog)
Pamela Frankel Fielder—oil (Pamela painted the hand)

Chapter 5
CHANGE OF SCALE

Hard to believe, but yes, your eyes can deceive you. Have you ever taken a piece of art to the gallery and suddenly it looks smaller than it did in your studio? Or perhaps you remember a series of objects differently than you remember one of the individual elements of that series? Or maybe the energy of a piece makes it feel larger than it really is?

By multiplying images, changing the point of view, varying the sizes of the elements in your piece and changing the scale, you can give your work the presence and power it deserves.

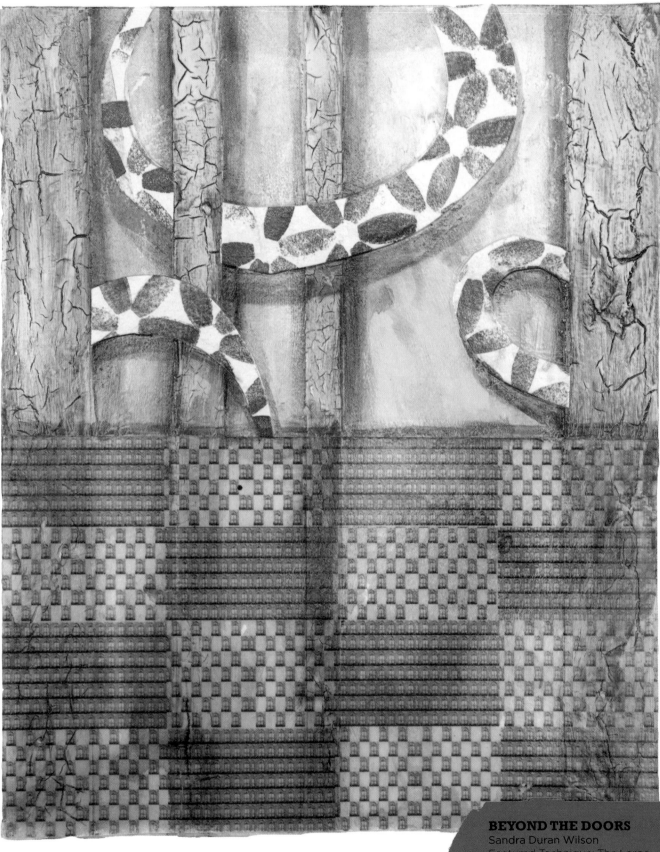

BEYOND THE DOORS
Sandra Duran Wilson
Featured Technique: The Large
and Small of It

Multiply Me

Let's play a game. If you see an individual person walking toward you, what do your think? If it was twins, would you feel different? What about triplets? Something about seeing multiples piques our interest. The repetition of form, whether realistic or abstract, creates a wonderful background upon which to build your art.

TECHNIQUE ONE: REPEAT

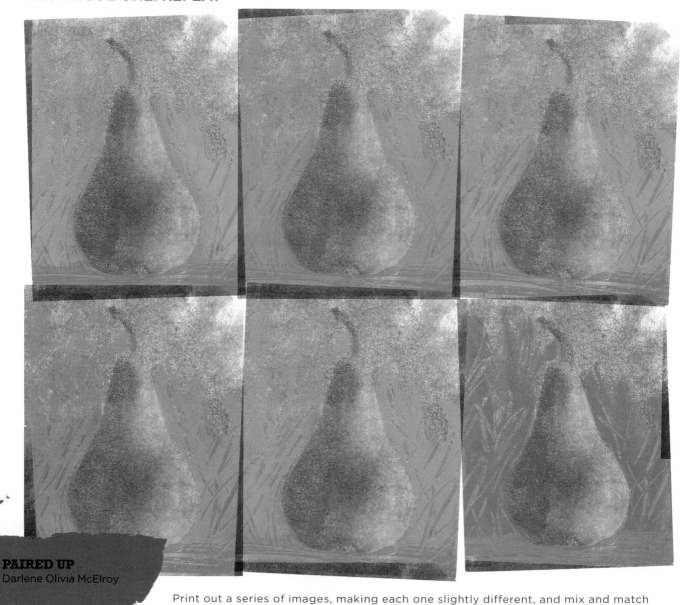

PAIRED UP
Darlene Olivia McElroy

Print out a series of images, making each one slightly different, and mix and match them. Or scan your drawing into a photo-editing program, multiply it, tweak position-ing and play with color.

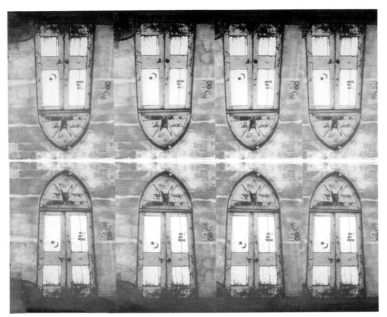

TECHNIQUE TWO: SIZE IT

You can enlarge your work to give it more presence or simply multiply an image to use as a background. Scan an image from a photo and print it out multiple times. Glue your printouts down on your surface or make transfers.

This piece is the background used in **REPETITION**, below.

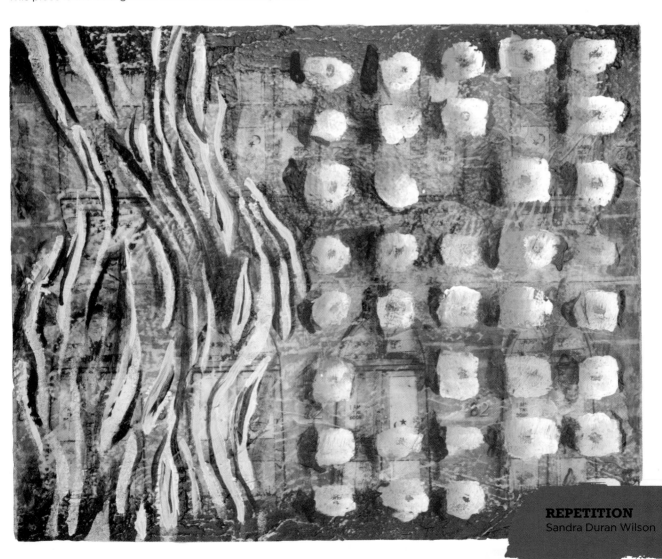

REPETITION
Sandra Duran Wilson

A Different Point of View

Entice your audience to look at your artwork by tilting elements, adjusting horizon lines or altering the viewing angle. Repeating images or changing scale can also place your art front and center. As viewers, we are so accustomed to how things are typically displayed that when an unusual element is introduced, it creates excitement and interest. Here are a few ideas to set you on your altered path.

TECHNIQUE ONE: TILT

By tilting the horizon line, a piece can become less static.

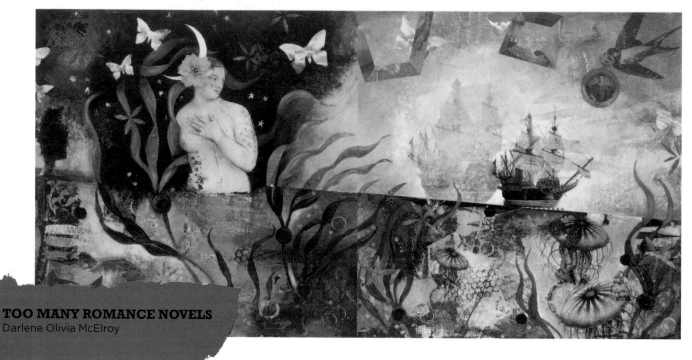

TOO MANY ROMANCE NOVELS
Darlene Olivia McElroy

TECHNIQUE TWO: THE BACK SIDE

A figure that faces away from the viewer gives pause. The viewer has a completely different experience with the art and might wonder what the subject is looking at. Imagination creates the storyline. I remember an old tintype I found in which all the subjects faced away from the camera. It aroused so many questions in my mind every time that I looked at it that it has since been burned in my memory.

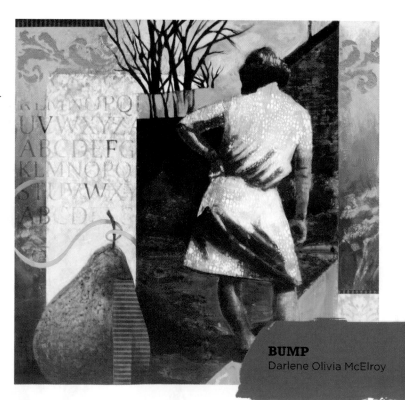

BUMP
Darlene Olivia McElroy

TECHNIQUE THREE: FOCUS

By changing the proportion of just a small part of an image, you emphasize a focal point to attract your viewer and guide them through your painting.

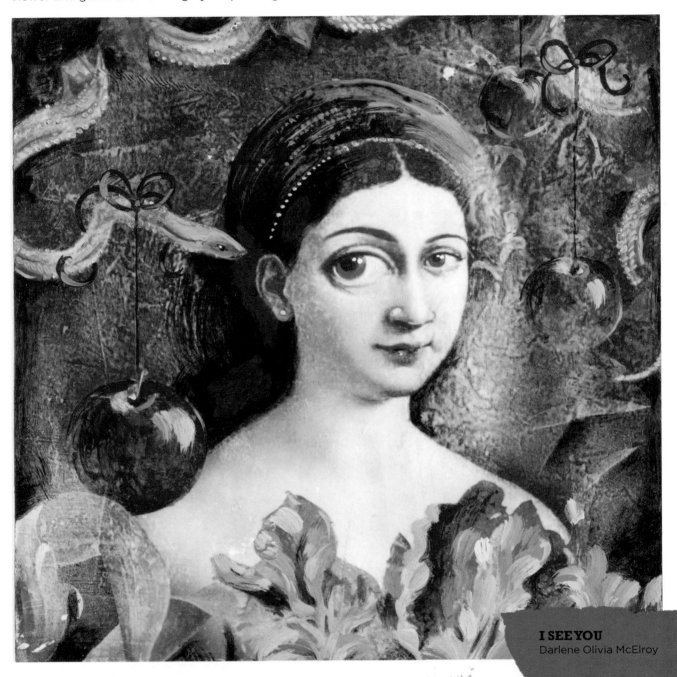

I SEE YOU
Darlene Olivia McElroy

More Ideas

- Viewing Angle: Whether from a bird's-eye view or a worm's view, change your perspective and you change everything. One easy way to try this is by painting or transferring an image onto a background at a not-so-typical angle. Can't you just feel the dramatic shift?

The Large and Small of It

When traveling to different destinations, I often come across outdoor sculptures of common objects made gargantuan. A twenty-foot-tall chair you can climb into brings out the child in most. On the flip side, miniature objects also have the power to fascinate. Playing with the scale of design, objects or elements can lead your eye through your art, tell a visual story differently, create emphasis or add playfulness.

TECHNIQUE ONE: WONDERLAND

Remember Alice in Wonderland? She was ten feet tall and then she was ... very small. Try playing with the large and small of it in realistic compositions. Make the rabbit huge or the child tiny. Or just alter the scale in a still life slightly to create tension within the painting.

TECHNIQUE TWO: ONE MORE TIME

Using multiples of an image that has a variation of scale can attract attention. Repetition and variation create a good foundational composition. (Photo by Sandra Duran Wilson.)

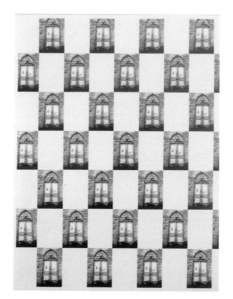

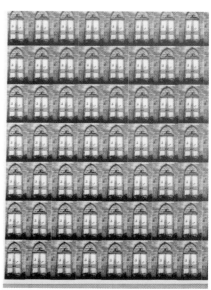

1 Choose a pattern or design that you have drawn or a photograph you love and make copies of it, varying the scale.

2 Make multiple images, flipping one or changing the color via your computer or copier.

3 Piece the images into an interesting pattern. Glue them to your surface and finish your art.

Size Makes a Difference

Yes, size can make a difference. Technology allows us to be like Alice in Wonderland, growing larger than life or seeing things microscopically. What fun we can have with the technology today! My mind spins thinking about what will be possible in the near future; maybe we will create art in a virtual reality. That will be nice, but let's get back to the present. Here are a few ideas to get you growing your next artwork.

TECHNIQUE ONE: SUPERSIZE IT

We've all seen the tiny dog straining at its leash to show the big dog who's boss. These little pups have large personalities. Do you have a small piece with the personality of a large painting? With today's technology, you can enlarge even miniature paintings to almost any size, depending on the quality of the photography. You can then have it printed onto canvas, watercolor paper, metal or Plexiglas. A fun way to test how your painting would look at a larger scale is to take a page from an architectural/interior decorating magazine and place an image of your painting on the page.

LOVING THE DRAMA
Darlene Olivia McElroy

Imagine the impact this painting might have if it were copied and printed to enormous proportions—it could easily become the focal point of an entire room. And how would you feel about this same piece if several very small copies of it were grouped together? Told you, size does matter!

TECHNIQUE TWO: ADD ON

Instead of one piece, create a trio or quartet of paintings that not only take up more wall space but are sold together. Try attaching several paintings together for a larger configuration.

Chapter 6
LOOSEN UP

Art is all about exploration, pushing boundaries and discovering who you are. This chapter will take you on a wild and crazy trip to the world of loosening up. You are going to explore your hidden creative side, and you'll discover strange new objects as creative tools. All the while, you will get physical with your art and become a brave art visionary. Your voyage will be fun, a little awkward and perhaps even scary at times. But when you return to earth, you will have acquired a new sense of freedom.

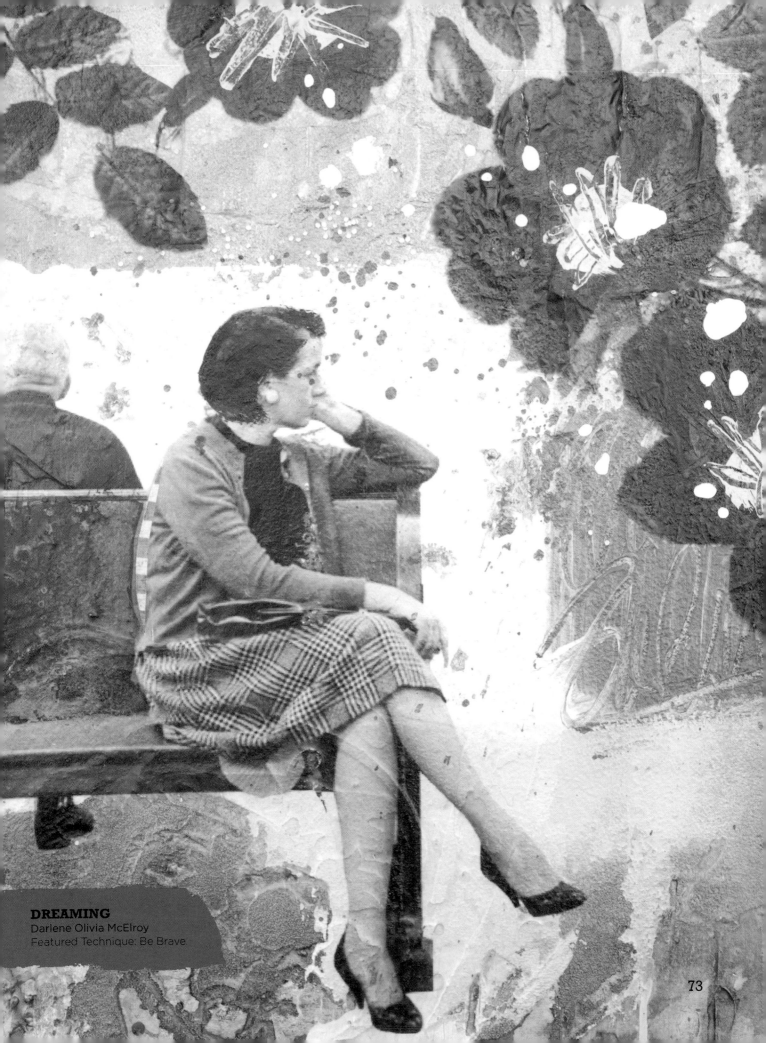

DREAMING
Darlene Olivia McElroy
Featured Technique: Be Brave

Find Your Opposite

This is the yin and yang of creating. Collage artist Robert Rauschenberg was a pro at incorporating both realistic and expressionistic elements into the same painting. When your painting is tight, you may want to compose an area of looseness to give it an element of surprise. For example, if you are a realistic painter and most of your painting has details that are similarly developed, you may want to incorporate a less defined portion. If you are an expressionistic painter, a bit of realism will give your work an unexpected pop.

TECHNIQUE ONE: TIGHTEN UP

If you already work in a loose and gestural style, consider adding a bit of realism. You can do this even if you do not draw well. Use an image transfer, such as a gel transfer, or print something from your computer and collage it into your painting. Try adding realistic shadows into an otherwise abstract painting.

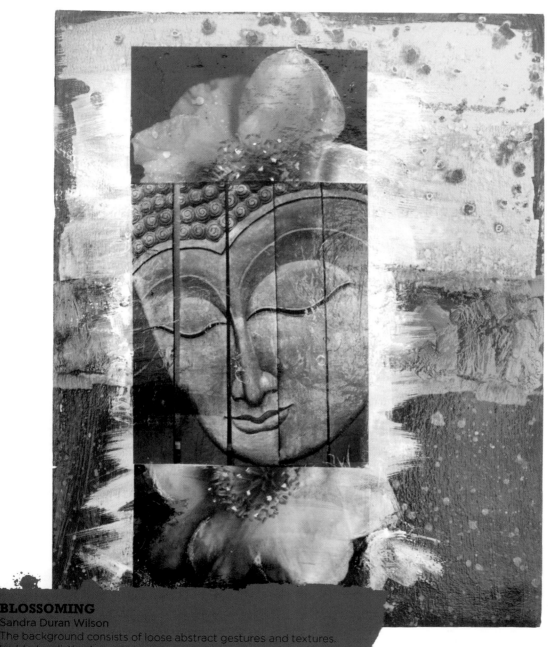

BLOSSOMING
Sandra Duran Wilson
The background consists of loose abstract gestures and textures.
I added realistic elements to create a tighter composition.

TECHNIQUE TWO: GET LOOSE

Perhaps you would love to try some gestural element in your otherwise tight painting. Think Rauschenberg; look up some of his work or add wonderful gestural, expressionistic movements to your painting by throwing paint at the surface, crackling or scribbling. If you are not ready for such a drastic combination, try loosening up some of your imagery. Leave out details and work with block shapes. It is amazing how much can be said with so little. Back up to view your art from a distance as it will change drastically with space.

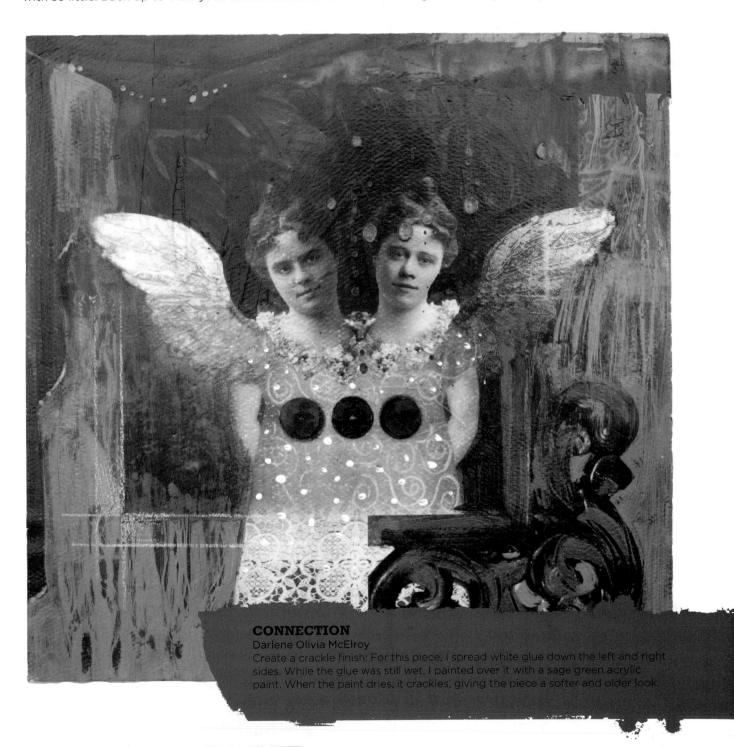

CONNECTION
Darlene Olivia McElroy
Create a crackle finish: For this piece, I spread white glue down the left and right sides. While the glue was still wet, I painted over it with a sage green acrylic paint. When the paint dries, it crackles, giving the piece a softer and older look.

For a **step-by-step demonstration of the Get Loose technique**, scan this QR code with your smartphone or visit createmixedmedia.com/mixed-media-revolution.

Mop It Up

Many of our students show up to class with small brushes or a few large ones and nothing in between. It shows where their comfort zone lies. This exercise will help you get beyond comfort. Yes, another growth opportunity. Look to the kitchen, aka the other art store, for some innovative art tools.

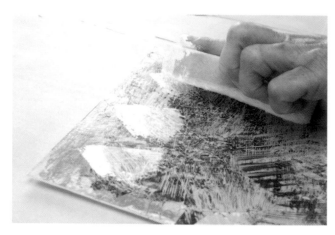

TECHNIQUE ONE: MOP IT UP

A sponge is a great way to apply paint, move it around and make great textures. It can also be used as a stamp.

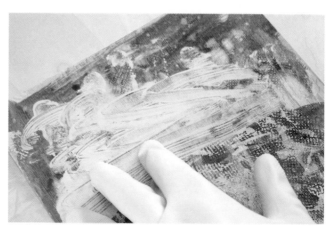

TECHNIQUE TWO: SMEAR IT

Do you have an old pair of kitchen gloves that have a hole in them and can't be used for dishwashing any longer? Don't toss them—take them to the studio. Use your gloves to smear paint around your canvas. Wipe off excess paint using your gloved hands and wipe it onto another surface.
Use a handprint as your signature.

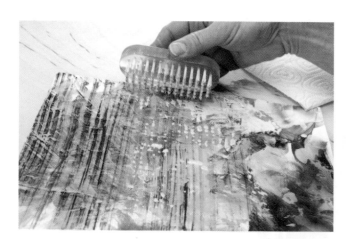

TECHNIQUE THREE: SWEEP IT

A brush or whisk broom is good for spreading your paint and infusing texture. Use the brush or broom to add texture with gel medium, let dry and then use your brush or broom to apply paint on top of the texture. Sounds crazy but the result is undeniably cool.

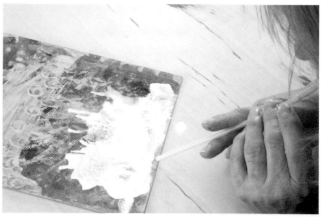

TECHNIQUE FOUR: BLOW IT

Buy a package of straws and store them in the studio before the kids grab them. Mix paint with a little water and put a few drops on your surface. Use your straw to create gestural lines by blowing air across the drops of paint.

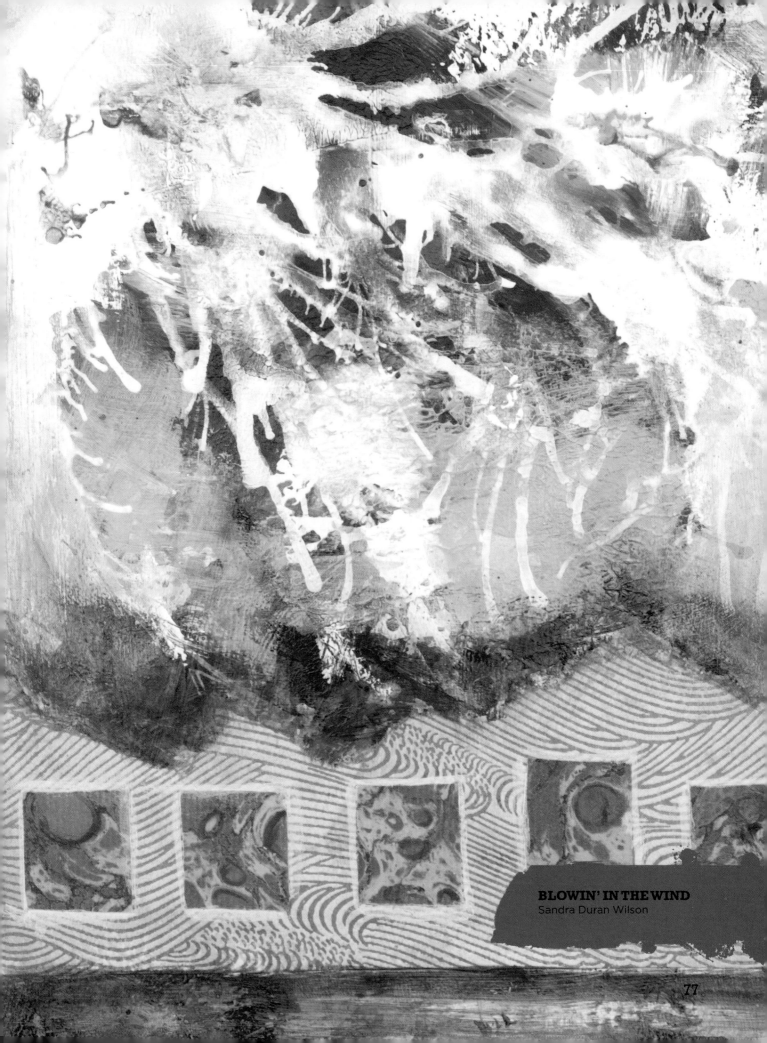

BLOWIN' IN THE WIND
Sandra Duran Wilson

Tango for Two

Art is a song of color; you are the conductor and the paint is the orchestra. Create to your favorite music or try intuitive painting using various genres of music. Play your favorite music to get in the mood to do the creative dance with your art.

TECHNIQUE ONE: DANCE ON IT

Color and music are beautiful dance partners.

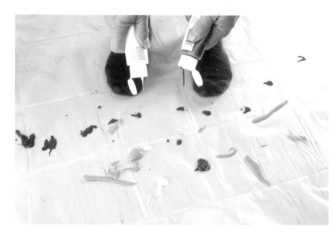
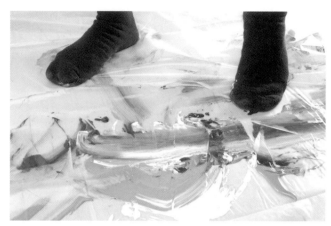
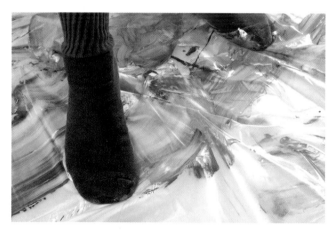
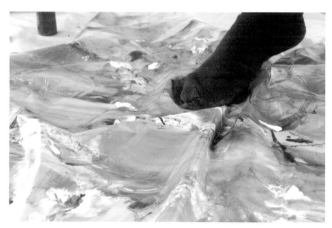

Try this: Pour paint on a plastic tarp and dance on the paint with old socks. Depending on the socks you can get some amazing texture. The amount of paint you use will make a difference as to whether you get a blend or texture. When the paint is dry, you can use the plastic for a Crazy Easy Transfer painting.

You could also dance directly onto fabric or canvas, but first put down plastic so the paint doesn't seep through the fabric to the floor. (FYI, this is a great way to use up leftover house paints.)

TIP
Put plastic bags on your feet first, then put on the socks.

To view **a video of the Dance on It technique,** scan this QR code with your smartphone or visit createmixedmedia.com/ mixed-media-revolution.

TECHNIQUE TWO: CRAZY EASY TRANSFER

Crazy Easy Transfer painting is a hybrid. It's kind of like monoprinting meets stamping with a painterly twist. This technique is wonderful for putting gesture, color, drips and runs exactly where you want them. This is a great technique for planning or altering a painting.

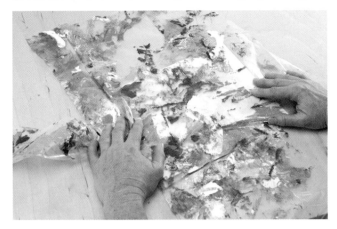

1 Arrange your composition by laying the painted plastic paint side down on your surface.

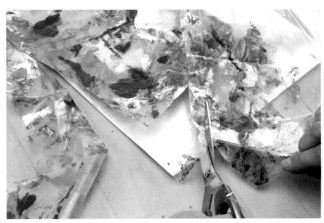

2 Cut out plastic pieces to fit your composition and surface.

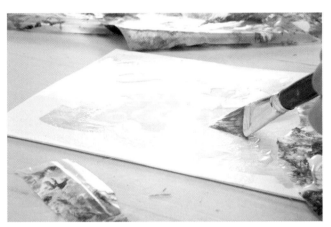

3 Paint your surface with gel or medium. (I've tinted this medium blue so that it will serve as a unifying element.)

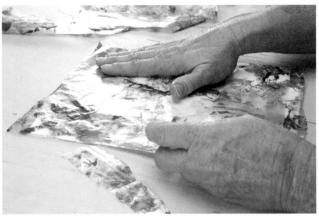

4 Lay the plastic over the surface paint side down and press firmly to adhere. Let dry.

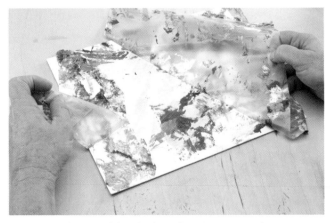

5 Once dry, peel back the plastic to reveal the transfer.

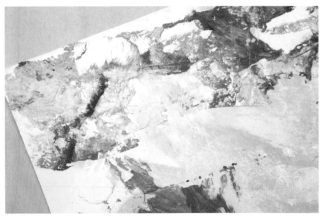

6 This finished piece will serve as a great background.

TECHNIQUE THREE: DISCOVER THE BEAT

Assemble an orchestra of black paper and pastels. Put together a varied play list ranging from meditative sounds to salsa and rock. You can close your eyes and feel the beat of the music. Take your time and begin to paint the sounds using the pastels on the black paper. When the music changes, grab another piece of paper and begin again.

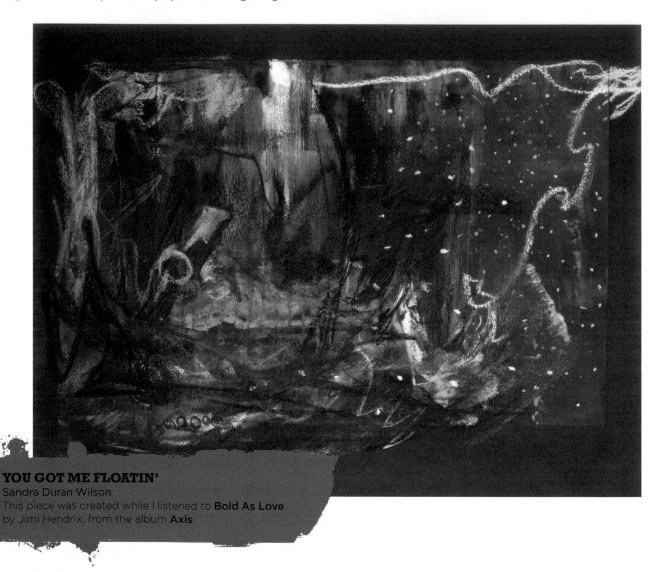

YOU GOT ME FLOATIN'
Sandra Duran Wilson
This piece was created while I listened to **Bold As Love** by Jimi Hendrix, from the album **Axis**.

TECHNIQUE FOUR: BE A CONDUCTOR

Get your canvas ready, load your brushes with paint and conduct the music. Throw the paint to a heady beat. Pollack you are.

TECHNIQUE FIVE: TURN THE BEAT AROUND

Dance around your easel and, with every spin, make a stroke on the canvas with your brush. If you are brave like I know you are, close your eyes as you do it.

Be Brave

For this one, we are going to ask you to be brave. You will move out of your comfort zone, loosen up and get out of your head. Trust us, you will end up feeling oh so good and proud. You are not going to think art but rather get physical with your art.

Set up your space so it is protected from paint. Use a painter's floor cloth or plastic tarp. Protect walls as well. If the weather is good, you can try this outside. Place your canvas, paper or panel in the middle of your protected space.

TECHNIQUE ONE: PITCH IT

Mix some acrylic paint with gel medium, and using a spoon or some container, throw the paint at the canvas. Practice using your best pitch. You can also mix paint with water or polymer medium. Pour this into a squeezable jar, like a plastic condiment bottle, and squirt or dribble your paint onto the canvas. Didn't that feel good?

TECHNIQUE TWO: SPRITZ IT

While the paint is wet, you can spritz it with water and watch those colors run. Pitch more paint at it if you want to alter it further.

TECHNIQUE THREE: BUBBLE IT

Put some wet paint onto your surface and while the paint is still wet, blow bubbles onto it. Yes, the kind of bubbles you get at the party or toy store. The bubbles will pop and leave behind some cool shapes.

TECHNIQUE FOUR: SPARKLE IT

Toss powdered mica, glitter or even powdered pigment at the surface for a special effect. Tilt and twirl your canvas around to get the paint to flow and blend. See, being brave is fun!

Chapter 7
PLAY WITH COMPOSITION

The mood of a painting is conveyed through composition as well as color or imagery. This chapter demonstrates some fun ways to work with composition using images, textures, color, lights and darks and copies. Double your exposure, preview colors and images, age your work, simplify it or make it wild and crazy. So much art to do and so little time—until now, that is.

We will show you how to test colors before making a commitment, preview shapes and images, get more art from your work and help to speed up your art process.

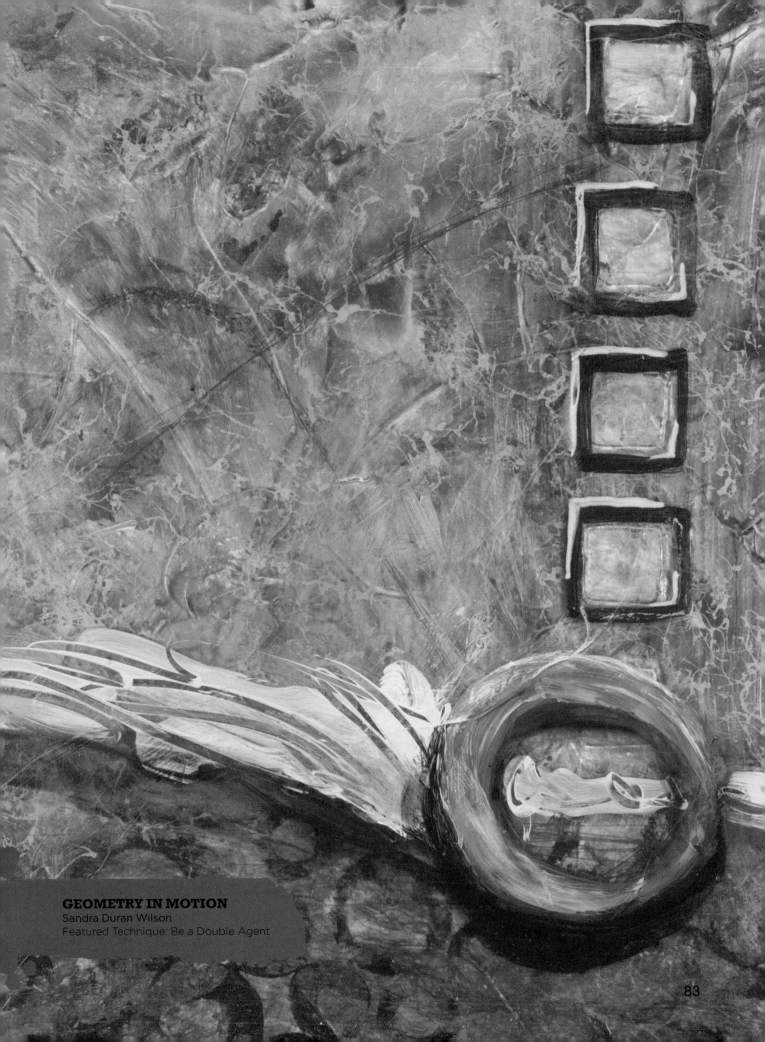

GEOMETRY IN MOTION
Sandra Duran Wilson
Featured Technique: Be a Double Agent

Check It Out

Not sure about the color you are thinking of using? Not certain if the object you want to use is the right size, the right element or the right color? These tricks can help you find the answers.

TECHNIQUE ONE: VIEW-MASTER
Do you want to know if that mark or area of color would enhance your painting?

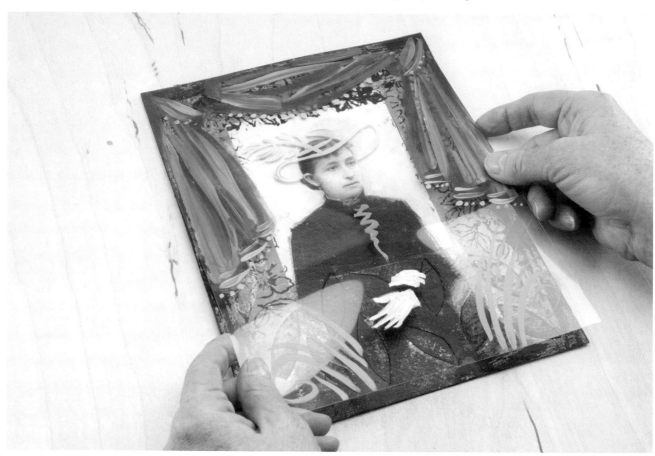

1 Cover your art surface with clear plastic like Mylar or plastic wrap.

2 Paint or put the marks you are considering on the plastic.

3 Let dry.

4 Don't like it? No problem. Just peel off the plastic. But be sure to save the plastic—it can be used later in a Crazy Easy Transfer painting.

TECHNIQUE TWO: PRINT IT
This is a great way to figure out if the element you want to glue down or transfer to your art is the right size or color.

1 Print or copy the element in different sizes. Trim it and tape to your piece.

2 You can move pieces around to see how their positioning affects the composition. Try different sizes. Experiment with different images and colors.

3 Make sure you put the work up on the wall and look at it from a distance. Then look at it in a mirror to see if the composition is right.

Keep It Simple, Silly

Is there so much going on in your piece that it is making your head spin? Is it so busy that the focal point has disappeared? Did you fill your canvas without leaving space for that image transfer? It is probably time to simplify and add a place for your eye to rest.

TECHNIQUE ONE: MAKE SPACE

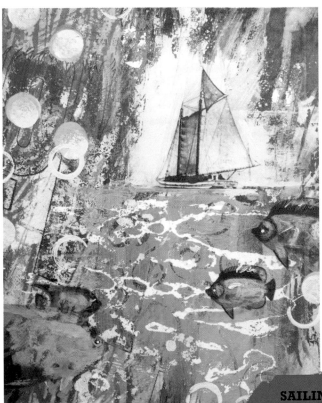

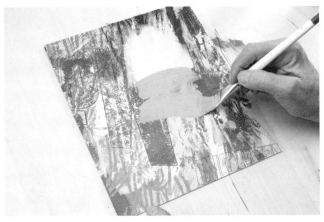

You have been diligently working on your mixed-media art and you now wish to add some elements to tell your visual tale, but the piece has become too busy. First select a mid to light tone or color from the piece; then, mix up some paint in that color and use it to stamp or scrape an area. Now you will have a simple quiet space to place your elements or transfers.

SAILING THROUGH AN EFFERVESCENT SEA
Darlene Olivia McElroy

TECHNIQUE TWO: QUIET IT DOWN

Have you ever been in an Oriental garden? The Oriental garden relies as much on the empty space as it does on the natural elements. It is this quiet space that gives the garden such a strong impact. Every piece of art needs a place of rest or a Zen moment or two to balance out the busy side. Take a step back and look at your piece. Hold your thumb out in front of your face. Look at the art and let your thumb block a portion of the piece to find where your Zen spot should go. Does the piece work just as well without this area? Paint into the area to quiet it down. You might also collage some element—like joss paper or book pages—over a busy area.

TECHNIQUE THREE: WASH IT

Add a diluted layer of white or tinted paint or gesso over a busy passage. You will be able to see what is in the background but it will be calmly unified by the color.

Be a Double Agent

No, we're not going to talk you into espionage but we are going to show you how to double your fun. Here is how you can put your brain to work creating depth and illusion. Let your ideas flow and see where the journey takes you.

TECHNIQUE ONE: I CAN SEE FOREVER

This is a fun way to create instant depth, and you'll be amazed to see the depth added by the reflective qualities of the metal leaf.

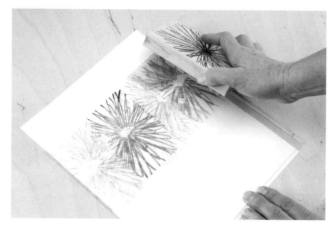

1 Stamp (or paint or transfer an image) onto a piece of Plexiglas.

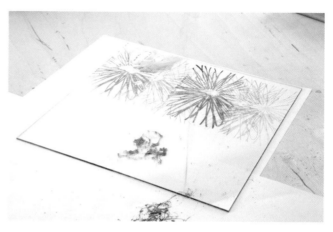

2 When the piece is dry flip it over and randomly apply spray webbing.

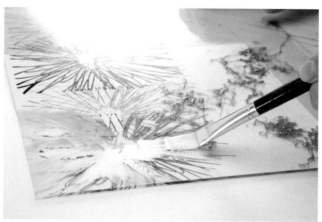

3 Paint over the reverse of the stamped images.

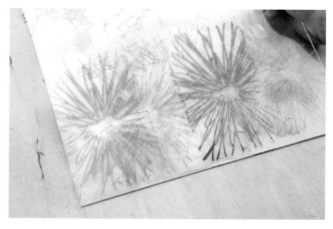

4 This is what the piece looks like so far from the "right" or stamped side. You can already get a sense of the depth created.

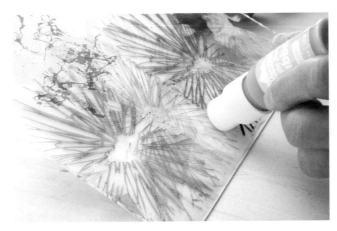

5 On the right side, add painted marks of your choice.

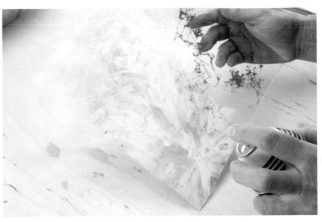

6 Then turn the piece over again and spray fixative on the painted and webbed side.

7 Lay a sheet of metal leaf on the fixative and press to bond the leaf to the surface.

8 Remove the backing paper from the leaf.

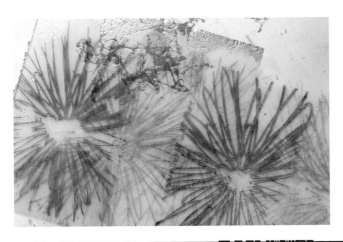

9 Admire the depth you've created. Incorporate additional elements and layers until you achieve the desired look.

TECHNIQUE TWO: BE A MAGICIAN

You can rearrange your composition at will. Create a grid of small paintings that can be reordered periodically to create a whole new work of art. Paint your art on small mat boards and then glue magnets on the back. You can arrange your composition on your refrigerator. Or start a magnet exchange program and you will find yourself appearing on refrigerators everywhere. Another option is to have a piece of metal cut and attach a wire for hanging. You can then attach your art to the metal and hang it anywhere.

All Mixed Up

Create your own piece of magic and train your eye to see composition within the composition. M.C. Escher was a master at doing this. Give your art new life by creating bold graphic elements both in your painting and on paper. You can use copies of your own images or magazine images for these great exercises in color and design.

TECHNIQUE ONE: BE BOLD

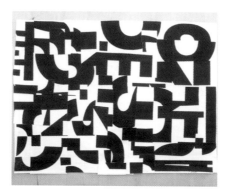

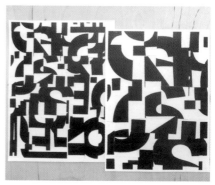

1 Words or strong graphics can be painted, stamped or printed from your computer.

2 Cut them into smaller shapes. You can use squares, strips or whatever shape you think will fit into your scene. Arrange the pieces to create a composition.

3 Make copies of your composition, and experiment with scale.

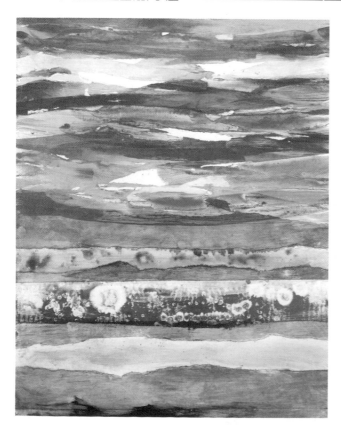

TECHNIQUE TWO: COPY AND PLAY

You can make copies of background papers that you have already painted or use magazine images cut up into small squares and sorted by color. Create your collage using these smaller images. You may use larger sizes to develop general shapes for your composition and then use the smaller ones to create the design within the composition.

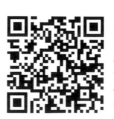

For a **full photographic step-by-step demonstration of a gel transfer**, scan this QR code with your smartphone or visit createmixedmedia.com/mixed-media-revolution.

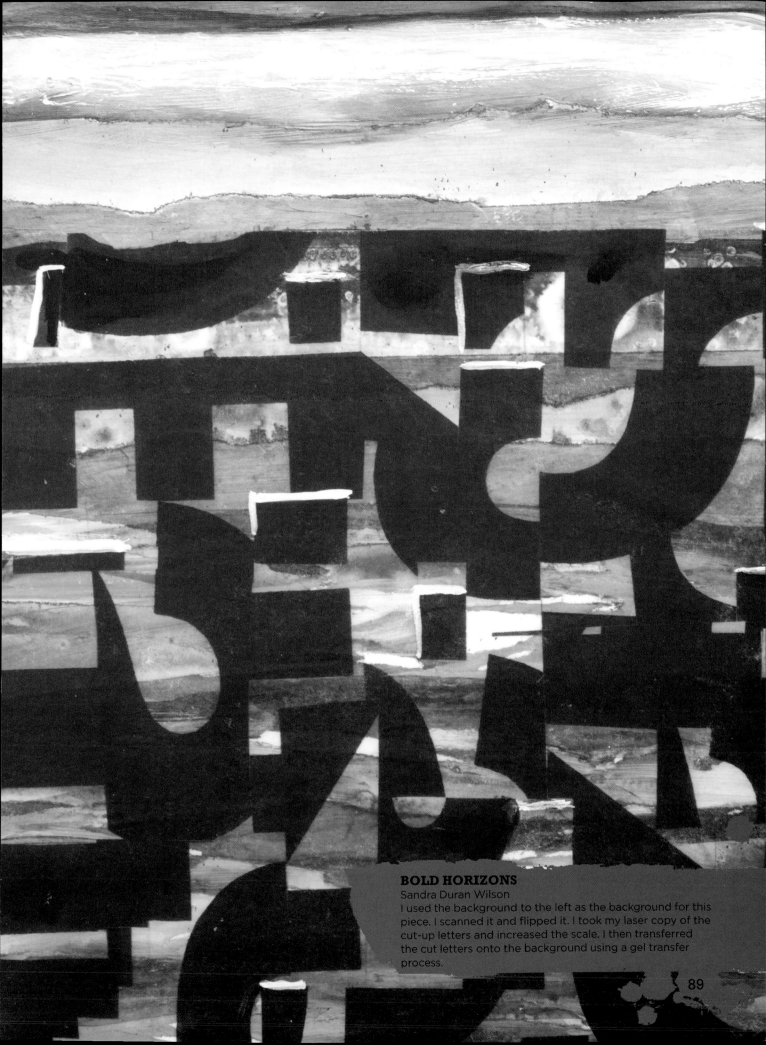

BOLD HORIZONS
Sandra Duran Wilson
I used the background to the left as the background for this piece. I scanned it and flipped it. I took my laser copy of the cut-up letters and increased the scale. I then transferred the cut letters onto the background using a gel transfer process.

Premonition

You have come to that proverbial fork in the road with your art and don't know which way to go. These techniques allow you to see into the future and get a peek at what your painting can be. You may have an idea of where you are going or you may want to go in several directions. We have a solution for that also.

TECHNIQUE ONE: PARALLEL UNIVERSE

Copy your background. Make one a true copy and copy a second one so it is backwards. You can develop each piece separately or put them side by side to create a parallel composition.

PARALLEL UNIVERSE
Sandra Duran Wilson

TECHNIQUE TWO: SCAN AND PLAY

Scan or photograph the painting background, then bring it into a digital photo-editing program. Many smartphone cameras come with special effects programs. You can play with color, crop, rotate, soften or sharpen areas and even layer multiple times.

TECHNIQUE THREE: LOW TECH

This is a very low tech but effective layering technique.

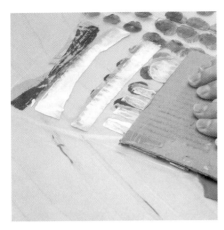 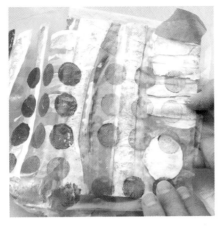 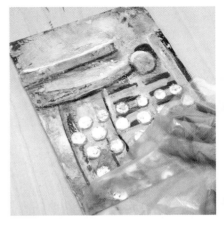

1 First, put a little piece of masking tape on a corner of a piece of plastic—a plastic bag or piece of painter's tarp works well. This will identify which side you are painting on. Sparingly stamp, paint or draw onto the piece of plastic. Let dry.

2 Turn the plastic over. This allows you to see what the paint will look like once it's transferred. Always paint on the same side of the plastic. Keep working and check your composition frequently.

3 Once you are completely finished painting and the paint is dry, you can then transfer the paint from the plastic to a panel or canvas using the Crazy Easy Transfer method.

TIPS

- Before you begin painting, put a little piece of masking tape on a corner of the plastic. This will help you identify which side you are painting on as you move back and forth between layering paint and checking your composition.

- If you want to know what a shape or color would look like in your composition before painting it in, cut out a shape from a magazine in the color you are considering and put it behind the plastic. You can move it around and change the size or color until you are satisfied. Then you can paint it into your work.

- When painting layers, leave some areas open so you can see through the layers. Your first layers should be very sparse. Build them up until you are satisfied with the look.

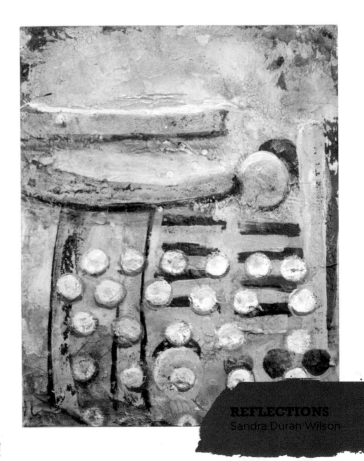

REFLECTIONS
Sandra Duran Wilson

Trace/Copy/Transfer

You don't have to worry about staying after school if you get caught copying because this is a whole different sort of copying! You can use these techniques to enhance your composition.

TECHNIQUE ONE: TRACE IT

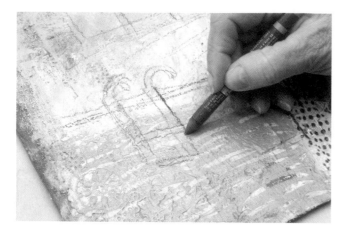 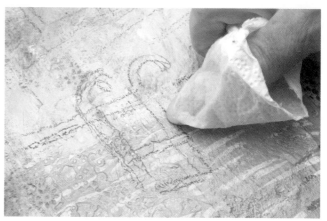

Place white or black graphite sheets under your image and trace it so it transfers onto your artwork. You can use sketches or photos on top of the graphite sheets. When your sketch has been traced, you can paint or use colored pencils to emphasize the lines. The white graphite sheets work well to get a light line drawing over a dark painting. You can always erase and move your sketch to another area prior to painting or coloring. Another option is to use a water-based crayon to sketch in your image. You can then wipe it off with water after painting in your image.

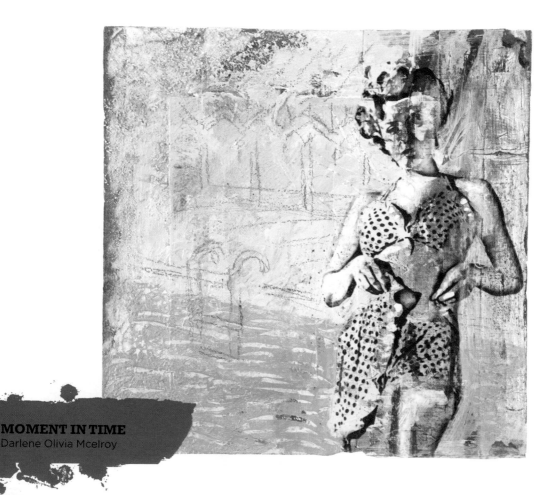

MOMENT IN TIME
Darlene Olivia Mcelroy

92

TECHNIQUE TWO: COPY IT

Repetition and variation are two of the major building blocks of composition. Take an element, shape or image that you wish to add to your art and copy it. You might copy different sizes or make many copies at a smaller scale. You could also try cutting the image up into pieces and adding it in pieces to your artwork.

TECHNIQUE THREE: TRANSFER IT

The difference between gluing down an element and making a transfer is that normally a collaged element is opaque and most transfers allow you to see the underlying background. Which will work best to tell your story and complete your composition?

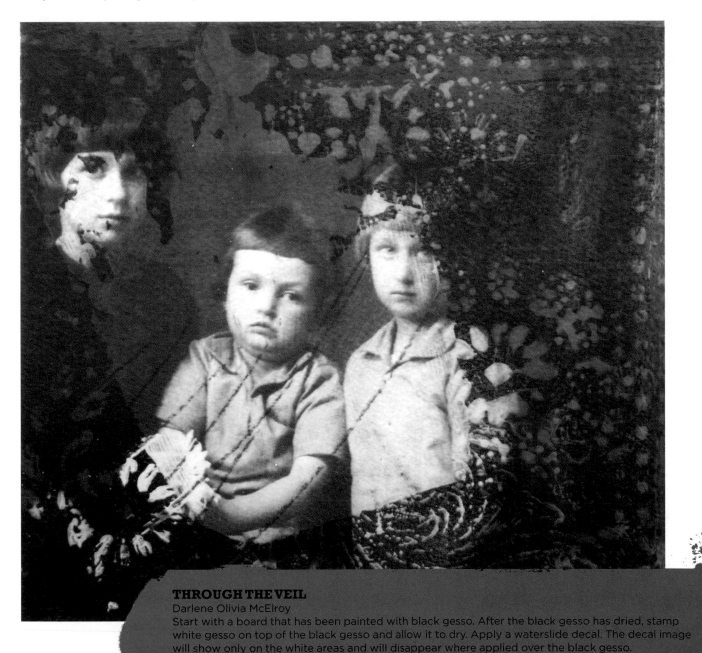

THROUGH THE VEIL
Darlene Olivia McElroy
Start with a board that has been painted with black gesso. After the black gesso has dried, stamp white gesso on top of the black gesso and allow it to dry. Apply a waterslide decal. The decal image will show only on the white areas and will disappear where applied over the black gesso.

Here and There

Time-worn patinas, old frescoes and ancient ruins all have something in common: an aged and incomplete look. We all know how to create a flawless image if we want to, but there is something intriguing and mysterious about providing only a hint of an image.

TECHNIQUE ONE: OVER HILL, OVER DALE

A heavily textured surface will give you a here-and-there image when stamped on.

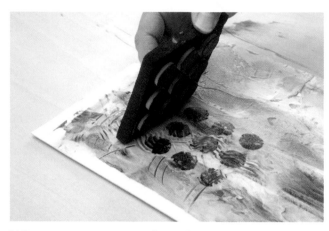

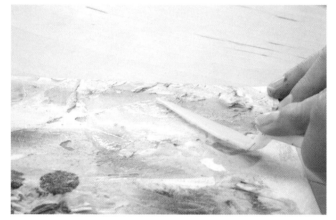

When you stamp on a heavily textured surface, the stamp only hits the high points and you get a broken up image.

Build up a textured layer with modeling paste and let dry. Glaze and then rub some of the glaze off. Let dry.

TECHNIQUE TWO: IRRESISTIBLE

Petroleum jelly creates a removable resist.

Using your fingers or a cotton swab, smear some streaks of petroleum jelly onto your surface. You can then drag tools through the jelly to remove some of it. Paint or stamp on top of this surface. When your paint is completely dry wipe, off the petroleum jelly. You may need to wipe several times to completely remove the jelly. The paint remains where there was no jelly, and the result is an aged look. You can continue to layer this in different colors. And a tip: Baby wipes are good for wiping the surface clean.

TECHNIQUE THREE: SIMPLY SANDED

Stamp or transfer an image to your surface. When it's dry, sand the image to give it a distressed, aged look.

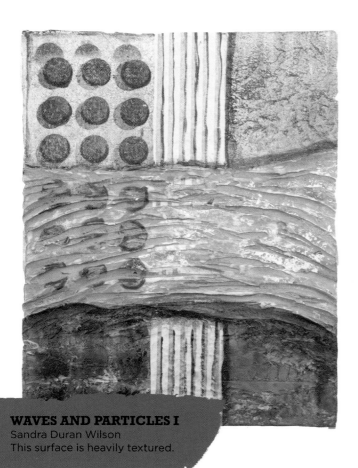

WAVES AND PARTICLES I
Sandra Duran Wilson
This surface is heavily textured.

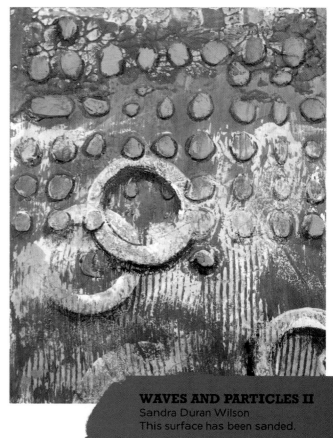

WAVES AND PARTICLES II
Sandra Duran Wilson
This surface has been sanded.

Chapter 8
FEAR NO COLOR

So much has been written about the power of color. The psychology and even physiological effects of color on the mind and body have been documented over time. Colors can push you away or draw you into a painting. They can make you see things differently or even change your mood. We all have our favorites and even our "safe" colors that we rely on. This chapter will help you be bold and inventive. You will experiment with color symbolism and layers, push your color boundaries and just play and enjoy the entire spectrum.

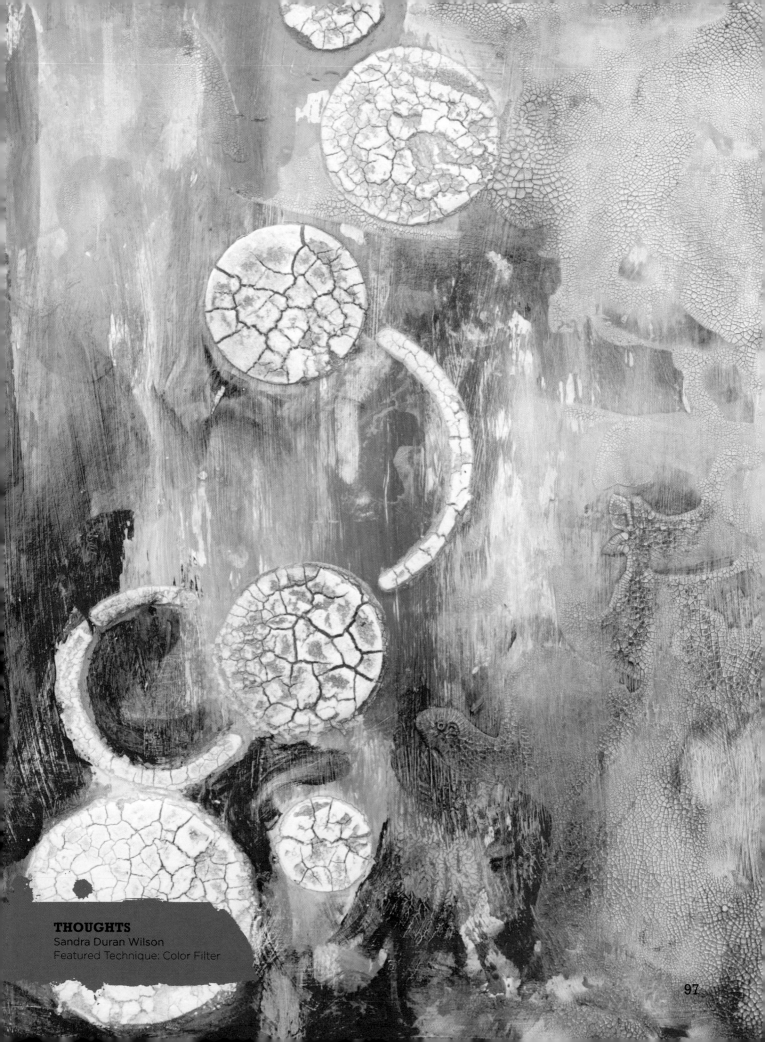

THOUGHTS
Sandra Duran Wilson
Featured Technique: Color Filter

Color Theatrics

Color can be dramatic, emotional and mesmerizing when it is pushed out of its normal range. Color your world the way you want to see it: Purple people, yellow skies and blue dogs can add an element of the unexpected to your work. Subtle shifts in hue alter the tone of a painting. Change the ordinary color or hue of an object to something more intense and add excitement to your art.

TECHNIQUE ONE: DRAMA—HIGH TECH

In this case, we pumped up the color in the sky, which went from blue to pink. Glue down your image, whether a toner-based image, magazine page or photo, and paint directly on it. Or just paint a section. Here's how to do it using Photoshop.

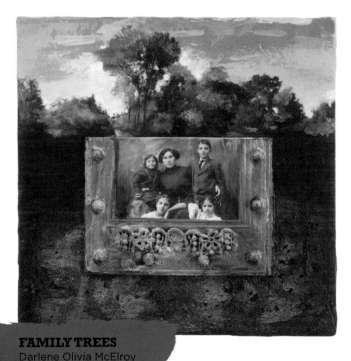

FAMILY TREES
Darlene Olivia McElroy

1 If you know how to use Photoshop start by scanning your image. In this case, I'm using a photo taken at a lake in northern California.

2 In the Photoshop menu bar, go to **Image > Adjust > Replace Color**. With the eyedropper tool, select the color you want replaced and change the color. We played with several color techniques before a pink sky was chosen for this example.

3 Print the image onto waterslide decal paper. (Toner-based decal paper is used here.)

4 Soak the waterslide decal paper in water until the emulsion starts to move. Then apply the decal to your surface with a polymer medium.

5 The background had been randomly painted and shows through the lighter areas of your transfer.

6 The transfer was painted over in certain areas so that it merged with the rest of the piece.

TECHNIQUE TWO: DRAMA—LOW TECH

1 If you don't have a photo-editing program, go to a local copy shop and play with color on the copy machines. Such copiers generally have color adjustment tools.

2 Play around until you come up with some fun color variations. You can experiment with saturation and hue and lightness and contrast. You also can print and collage the images or use your printouts as reference images for your paintings.

Conquer Fear

Do you wish you were looser with your color and could throw paint splashes on your canvas or splatter color across your precious painting? Do you fear making such a commitment? With this trick, you can appear wild and crazy while actually remaining in control. You can add those drips, splashes and swashes just where you want them.

1 Drip, drop, splash or draw with your paint(s) on gampi tissue paper. Gampi is a silk tissue paper that "disappears" when glued down with acrylic polymer. After it is glued down, let it dry. Then trim the gampi around the painted areas so there is no excess.

2 Experiment with the placement of your gampi paper cut-out to determine optimal color and placement.

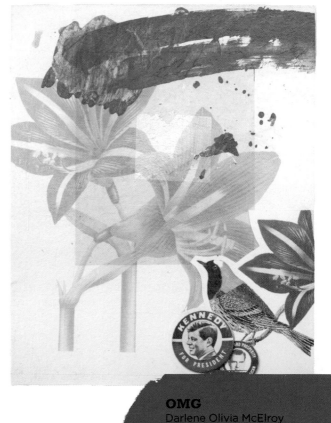

3 Then paint over the surface with polymer gloss that has a bit of water added. Lay the gampi tissue where you want it and continue brushing, from the center out to eliminate creases and bubbles. When the medium dries, you will see the paint but not the paper.

OMG
Darlene Olivia McElroy

Cut It Up

Create jewel-toned color gel skins and cut them into shapes to add sparkle to your art. Beautifully textured and opaque shapes will give your art that extra zing. These shapes can be made using acrylic gels or pastes. Depending on the gel or paste used, you can create texture, opacity or transparent color. Any of the following gels will work: pumice gel, glass bead gel, tinted soft gel or a gel you make yourself. Gloss gels will result in the clearest skin, and pastes will give you opaque skins. I love working with light modeling paste, heavy modeling paste and fiber paste.

TECHNIQUE ONE: CUT IT

You can make sheets of acrylic skins with any acrylic paint, pastes or gels. You can even embed objects such as buttons, mica, beads, sand or whatever else you can think of into the wet gels and pastes.

1 Spread out your paint, paste or gel onto a polypropylene piece of plastic. Add glitter, bead gel, sand, etc., if desired. Let dry.

2 While the medium is still on the plastic, cut it into desired shapes and glue paint side down on desired surface using polymer medium or gel. Let dry.

3 Peel off the plastic.

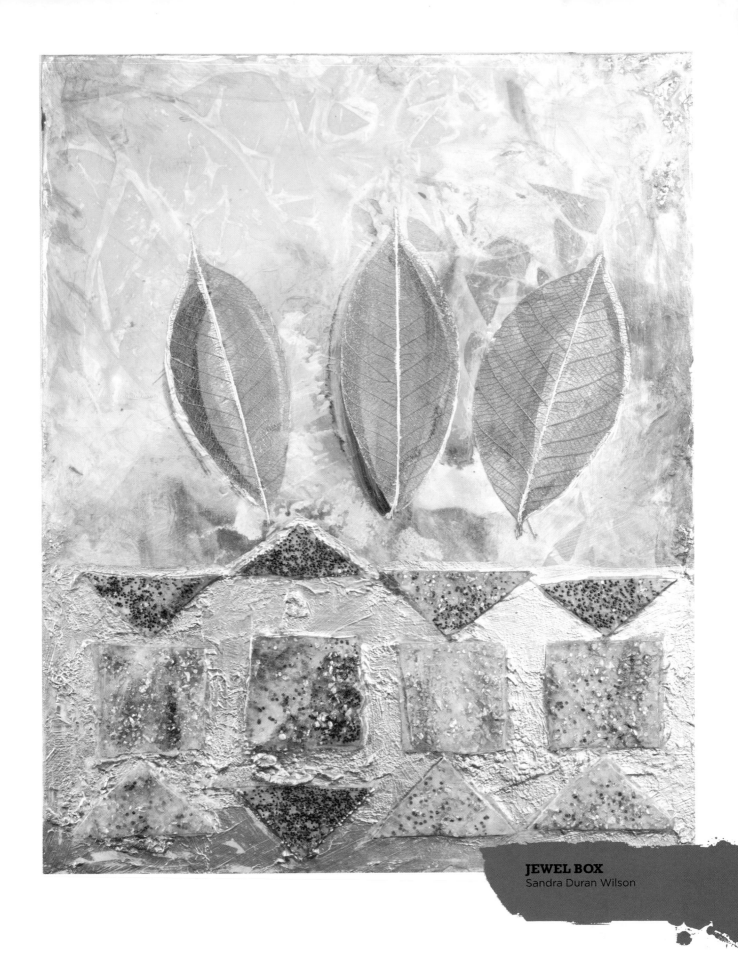

JEWEL BOX
Sandra Duran Wilson

TECHNIQUE TWO: IRON IT

This technique is great if you need a lot of small shapes. It works only if you will be putting the pieces onto an acrylic painting.

1 Create your gel skins on a piece of plastic, as previously described, or use a plastic cutting board for added texture. If you use a cutting board, don't use it in the kitchen again—keep it in the studio. Let the gel skins dry completely.

2 Peel the skin off the plastic or cutting board and cut it into small shapes. Place the shapes onto your acrylic surface.

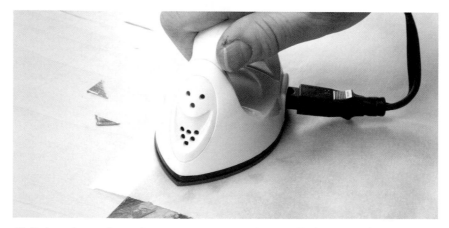

3 Put a piece of parchment paper over the small pieces and use a medium-hot dry iron to fuse the shapes to the acrylic surface. Let cool and remove the parchment paper. No glue necessary!

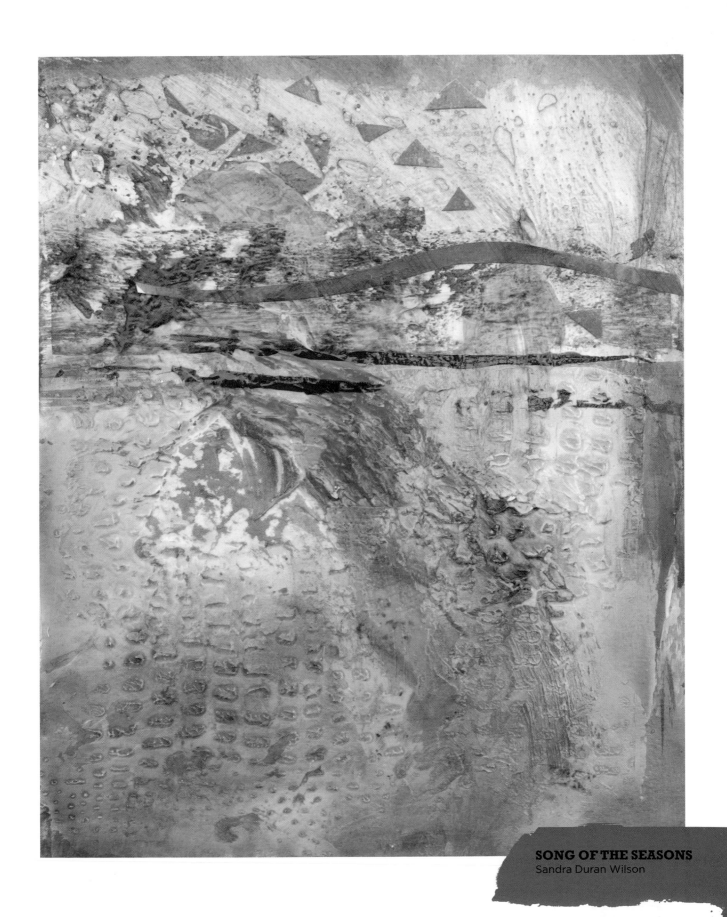

SONG OF THE SEASONS
Sandra Duran Wilson

Be a Famous Artist

We all have favorite artists who inspire us. Perhaps one artist inspires your color choices, another your compositions and someone else, your point of view. We learn from these artists by emulating their techniques. Here are a few exercises to get you started on your path to mastering your domain.

TECHNIQUE ONE: WARHOL WANNABE

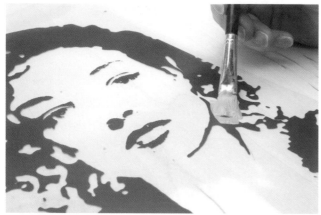

Scan an image into a digital photo-editing program or go to the copy shop and convert it to black-and-white high contrast. Print it out multiple times onto transparencies or Mylar. On the back side, paint with acrylics, using a different color for each one. Try color glazing to keep it transparent and soft. When dry, flip it over and glue it down. You have an Andy Warhol-type image.

TECHNIQUE TWO: LOUISE ME

Glue a variety of dimensional objects on a board a la Louise Nevelson. Keep composition in mind as you play with shapes and textures. Spray it all one color, preferably in the wonderful Nevelson black, and watch how shadows work on a tonal piece.

TECHNIQUE THREE: BE A PICASSO

Do three figure drawings or paintings in different sizes, including at least one full-face drawing and one profile. Cut them up and rearrange them into three different pieces of art. You will learn about composition and color relationships, and it just might surprise you to discover what a good Picasso you are.

TECHNIQUE FOUR: CLOSE TO YOU

For a Chuck Close variation, take a close photograph of a face. Lay this under some plastic and dot paint with a pencil eraser in different colors to cover the face. When the paint is dry, transfer the piece to a canvas or panel via Crazy Easy Transfer painting. The beauty of this technique is that, when viewed from a distance, the color dots merge to create a cohesive image.

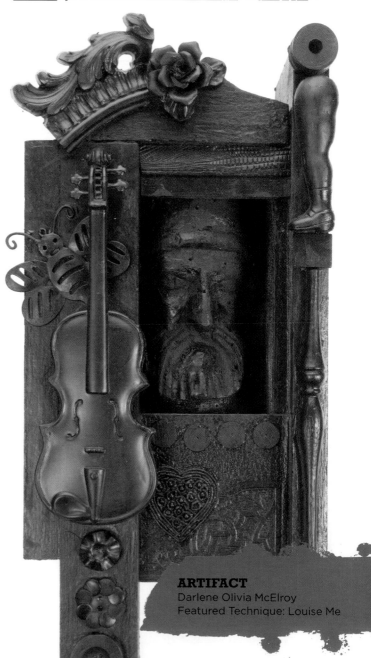

ARTIFACT
Darlene Olivia McElroy
Featured Technique: Louise Me

Color Filter

Glazing can completely alter the impact of a color. The complement, or opposite color on the color wheel, can tone down a too-bright color. If you have a painting and the green is just too much, a red glaze will tone it down. Sometimes you end up with a piece in which the different parts of the painting aren't "talking" to each other. A unifying glaze over the entire piece may be the answer. Let us show you how to test a glaze before taking the leap.

A glaze is a tiny bit of paint color mixed with a glazing medium. Glazing medium is usually an acrylic polymer medium with a retardant mixed in to keep it from drying too fast. Glazing mediums come in gloss, matte or satin.

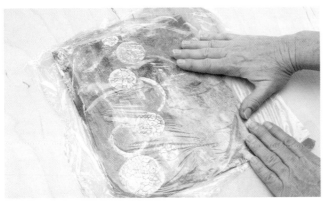
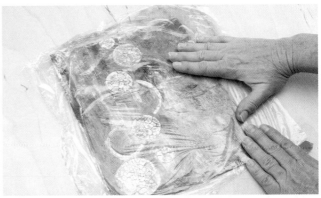
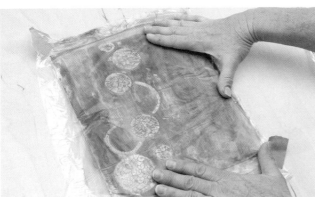
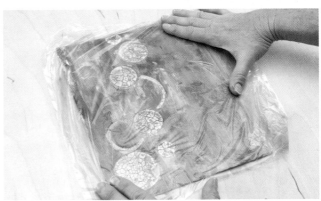

1 Put a piece of clear plastic wrap or painter's tarp over the area you wish to apply the glaze. Mark the side of the plastic you are working on by adding a small piece of painter's tape.

2 Mix the paint into a pool of glazing medium. Use the tip of a palette knife to add tiny amounts of color to your glazing medium. Keep adding color to the glaze until you get the mix you desire.

3 Paint the plastic that covers the area you wish to glaze. Evaluate the color.

4 You can test-drive different glaze colors' ability to unify a painting, warm it up, cool it off or tone it down—just experiment with different glazing colors.

5 When you have decided which color works best, paint that color directly onto your painting. Remember, you can always rub some of it off for a bit of contrast.

Dream in Color

Color theory haunts my dreams. I am often caught off guard because I am thinking of color. Colors appear one way alone and can become magically transformed when placed next to another color. The colors in my dreams can't be seen with the waking eye. Perhaps in a distant future we will discover ways to see those dream colors.

In the meantime, grab a handful of color chips from the paint store and try mixing and matching to see what happens visually. Make your own color chips using iridescent and interference paints. To spice up your color options even more, make color chips using different kinds of metal leaf. You'll be able to see, for example, how a certain color would look against a coppery leaf. Experimenting this way will save you a lot of time later and you will find some very cool combinations.

TECHNIQUE ONE: IMPACT

It is definitely worth having a color wheel in your studio for easy reference. Three easy ways to get color drama are:

Complementary Color: Opposites attract, right? Placing an fuchsia color next to a green has major punch.

High-Contrast Colors: The extreme would be black against white. Your eye will gravitate to the place where your darkest darks and lightest lights come together.

Cool Against Hot Color: If you have a painting that is warm, use some cool color accents to give it pop. Do the reverse if the painting is too cool.

TECHNIQUE TWO: BRIGHTEN IT UP, GRAY IT DOWN

Color theory can improve your art by giving it more impact and balance. Many books and websites address this subject. Learning about high and low key colors and how they can have varying levels of color saturation will get you started.

TECHNIQUE THREE: COLOR KEY

Color key is the overall brightness and chroma (color saturation) of a painting. High and low key paintings can have varying levels of color saturation. It's the use of lights and darks, saturated and desaturated color, that makes a piece of art pop, not unlike the use of sweet and sour or salt and sugar in a recipe.

FADED MEMORIES
Darlene Olivia McElroy

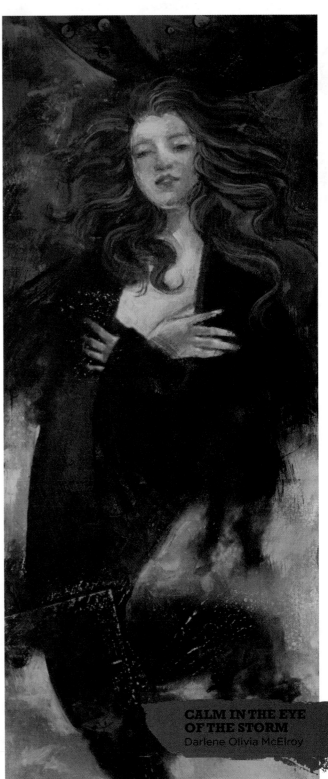

High key paintings are on the light end of the value scale and can be achieved with the addition of white to your color. In all three of these samples you can see at least a hint of color in the lighter values. Combine high key color with darker images to give your piece focus, like in the piece above.

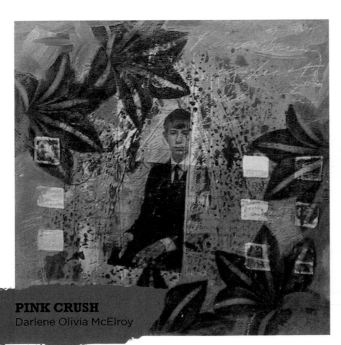

PINK CRUSH
Darlene Olivia McElroy

CALM IN THE EYE OF THE STORM
Darlene Olivia McElroy

The varying saturation of one color in a piece can give you both quiet and loud areas.

Low key paintings tend toward the darker end of the value scale. Think of the sea or a cityscape at night—one in which you can barely see color in the darkness. Add a glow of a lighter color and now you have a focal point.

107

Chapter 9
TEXTURE WHERE YOU WANT IT

The best art may never come into existence as long as you have a fear of ruining something that is precious to you. How many times have you considered adding wild gestural strokes, splatters or drips but stopped yourself because you're afraid of messing up your art? Well, put your what-ifs behind you, because we have an ESCAPE key, just like the one on your computer! You can control chaos, and we'll give you the secrets to testing the waters first.

Whether you want to embellish with drips and splatters, shapes, crackle or drawings, you have the power to test them out before you commit.

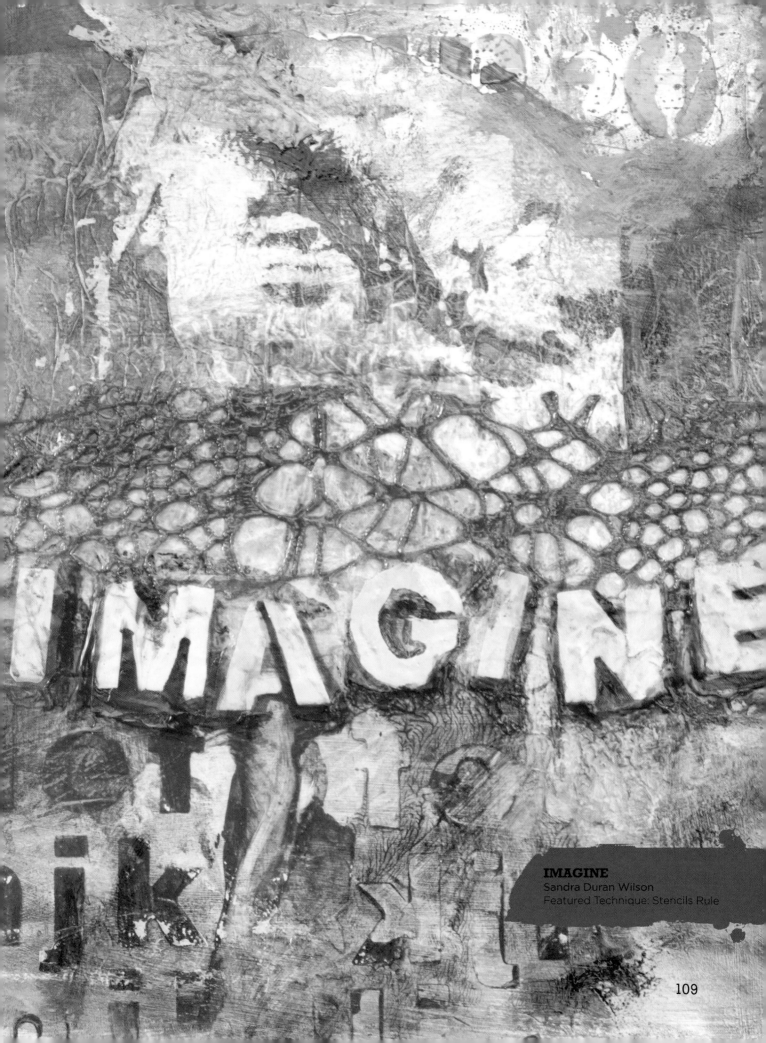

IMAGINE
Sandra Duran Wilson
Featured Technique: Stencils Rule

Controlled Chaos

Do you like the idea of wild gestural strokes and splatters but find yourself taking a more restrained approach to art? Try this technique; it will make you feel empowered. Using this method, you can be loose in a controlled, precise way, and no one will know you didn't just pour the paint on your art surface in a wild Pollack style.

TECHNIQUE ONE: BRUSH IT

1 Cut out a piece of gampi paper to cover the area you will work with.

2 Place the paper over your painting and brush on paint or glaze. Evaluate the color.

3 If you like the effect, let the paint dry. If the effect is not what you were hoping for, you can peel off the paper.

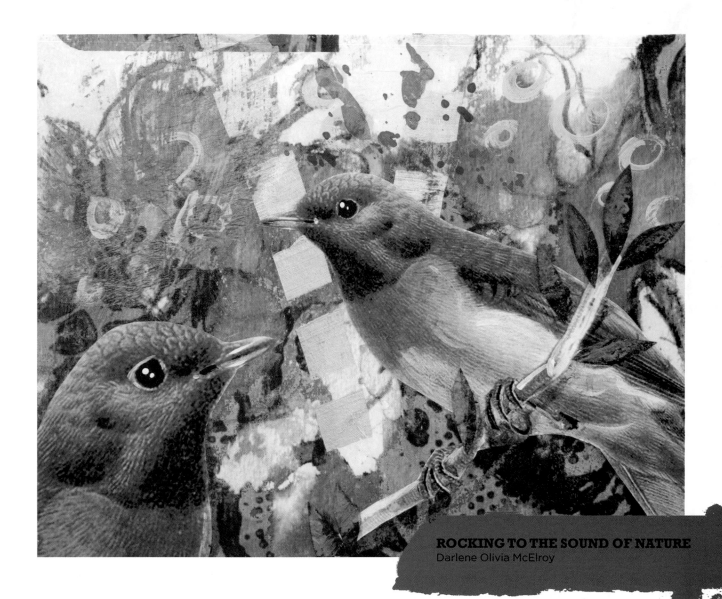

ROCKING TO THE SOUND OF NATURE
Darlene Olivia McElroy

TECHNIQUE TWO:
SPLATTER IT

1 Splatter paint onto plastic wrap or some other type of plastic with a toothbrush or paintbrush. Allow the paint to dry. You'll get different kinds of splatter depending on the wetness of your paint.

2 Brush polymer medium or soft gel onto your surface.

3 Lay the painted side of the plastic face down and brayer. Let dry.

4 Peel off the plastic and your drips will now be on the surface of your art.

TECHNIQUE THREE:
POUR IT

1 Pour self-leveling gel or polymer medium on plastic.

2 Add drops of wet paint or acrylic ink.

3 While the gel medium is wet, move the four corners of the plastic up and down to swirl the color.

4 Let dry and then peel the medium off the plastic. Apply as desired to your artwork.

TECHNIQUE FOUR:
ICE IT

1 Mix a little paint into a soft matte gel.

2 Use a cake spatula to spread the gel onto the plastic.

3 Let dry.

4 Peel the dried gel off the plastic and glue it to your painting with polymer medium or soft gel as desired.

Stencils Rule

Were you a cut-up in school? No? Well, here's your chance to have fun cutting up with stencils and scissors. This is a great way to use leftover paints and gels instead of throwing them away. Keep clear plastic bags on hand for this great technique.

Typically when using a lettering stencil with gels, paints or pastes, you have to do one letter at a time and let each one dry before proceeding to the next. Here is a great way to make your letters all at once. You have to make them backwards, but that's easy enough to do with a stencil. Then pretend you're Vanna and flip your letters to arrange your words!

1 Mix your paint into some gel or paste to increase viscosity. Lay your plastic flat and tape it down to keep it from moving. Flip your stencil so it is backwards and paint your first letter. Move your stencil to another area of the plastic so you won't smear the wet paint. Continue until you have made all the letters you'll need for your word, and let dry.

2 When dry, cut up the plastic letters and put gel medium onto the surface where your letters will be attached. Flip the letters and gently press them into the surface. Continue until you have your word spelled out.

TIPS

- Polypropylene plastic is the type of plastic that acrylic doesn't stick to. It comes in the form of plastic bags, trash bags and plastic drop cloths.

- Oops, you didn't flip your stencil! No problem. Let the letters dry completely, peel them off the plastic and adhere where you like.

3 Let dry completely and peel off the plastic.

For a **step-by-step variation on the Stencils Rule technique**, scan this QR code with your smartphone or visit createmixedmedia.com/mixed-media-revolution.

Distressed Dryer Sheets

Used dryer sheets can be painted, printed on and even distressed. They can then be used as textural collage elements.

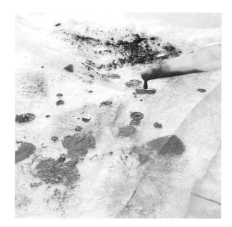

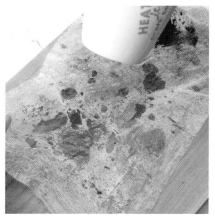

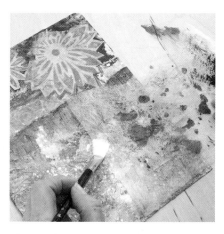

1 Place the dryer sheet on top of plastic to protect your work space. Paint the sheet. Let dry.

2 Use a heat gun to distress or melt the fabric. The areas free of paint will melt. (You should work in a well-ventilated area.)

3 Apply gel to your surface and place the dryer sheet on top of the gel. Apply more gel over the dryer sheet and let dry.

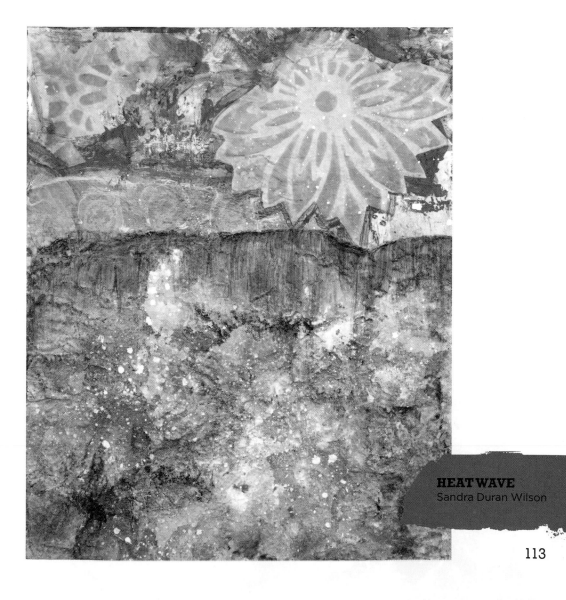

HEAT WAVE
Sandra Duran Wilson

All Cracked Up

Crackle textures are so cool—you get both depth and color variations. Each of the many different types of crackle mediums has its quirks. You pretty much just have to put them directly onto a rigid surface and wait to see what happens. But what if you want to have a bit more control over the texture, color or shape? Read on.

TECHNIQUE ONE: CUT UP

1 Pull out your handy clear polypropylene plastic and spread some white glue onto it.

2 Take your acrylic paint of choice and, using a brush, float it on top of the wet glue. Don't mix it into the glue.

3 Let the glue and paint dry completely. The cracks will follow the brushstrokes. They will be larger with a thick layer of glue and smaller with a thin layer.

4 When dry, you can cut the crackled mixture into shapes.

5 Apply soft gel medium onto your surface. Put the shapes crackle side down and press out any air bubbles.

6 Let dry completely and pull off the plastic. You may want to put a layer of clear polymer medium over the crackle to seal it and keep it from getting sticky if it gets wet.

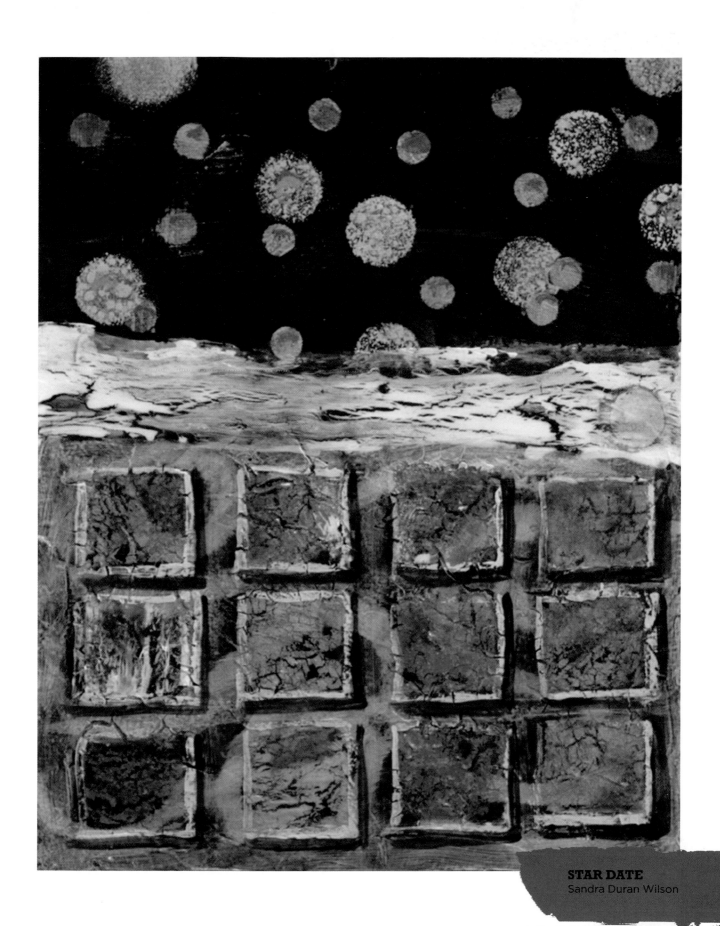

TECHNIQUE TWO: CRACKLE STENCILS

Crackle pastes are opaque and white. When dry you can add glazes or washes and the color will gather in the cracks. You can also use them with your own stencils or purchased stencils.

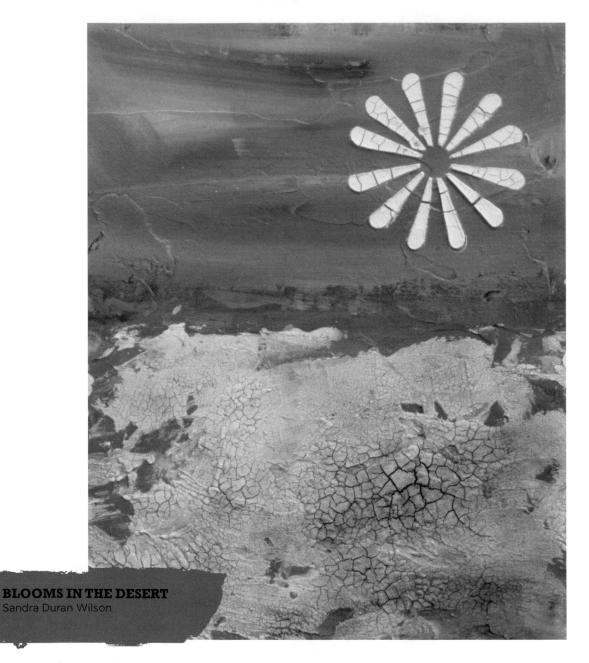

BLOOMS IN THE DESERT
Sandra Duran Wilson

1 Decide where you wish to place your shape and, using a palette knife, press the crackle paste through the stencil.

2 Pull the stencil up and let the paste dry.

3 When the paste has dried, mix paint with a bit of water and brush it over the paste. The color will seep into the cracks and you can easily wipe off any excess from the surface.

4 You may layer on more colors, but make sure they are diluted with glaze or water.

5 When dry, you can sand the surface to reveal the underlying white crackle paste, if desired.

Finger-Painting Memories

If you have forgotten how much fun it is to play, this technique is perfect for you. You can spend hours having fun and then save your results for another day, month or year. You will have created elements of art that you can use anytime in the future. Plus, you can get messy and no one will yell at you because it's **art**. This is also great fun for the whole family.

TECHNIQUE ONE: FINGER PAINTING

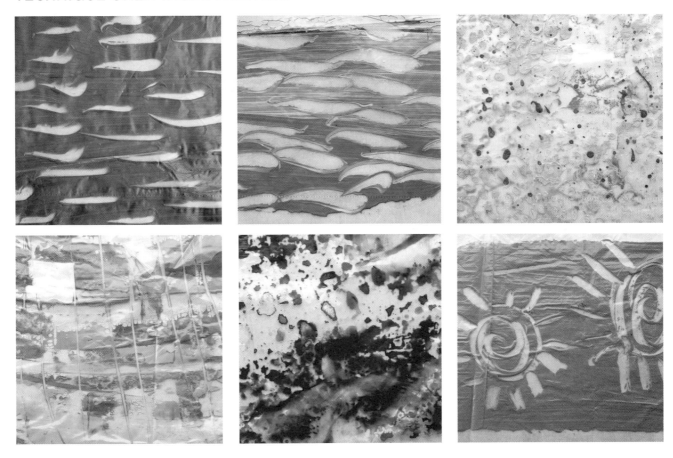

1 Brush a layer of paint or paint mixed with gel onto polypropylene plastic.

2 While it is wet, draw into it with your fingers or whatever tool is handy.

3 Let dry.

4 Brush polymer medium or soft gel onto your surface.

5 Lay the plastic painted side down and use a brayer to adhere it to your surface.

6 Let dry. This can take anywhere from one hour to days depending on the surface and size of the transfer.

7 Peel off the plastic and your finger painting will now be on your art surface.

TIPS

Transfer your finger paintings onto stiff interfacing or Lutradur using white glue, and use them in book projects.

You can keep these sheets of paint on plastic for years before use.

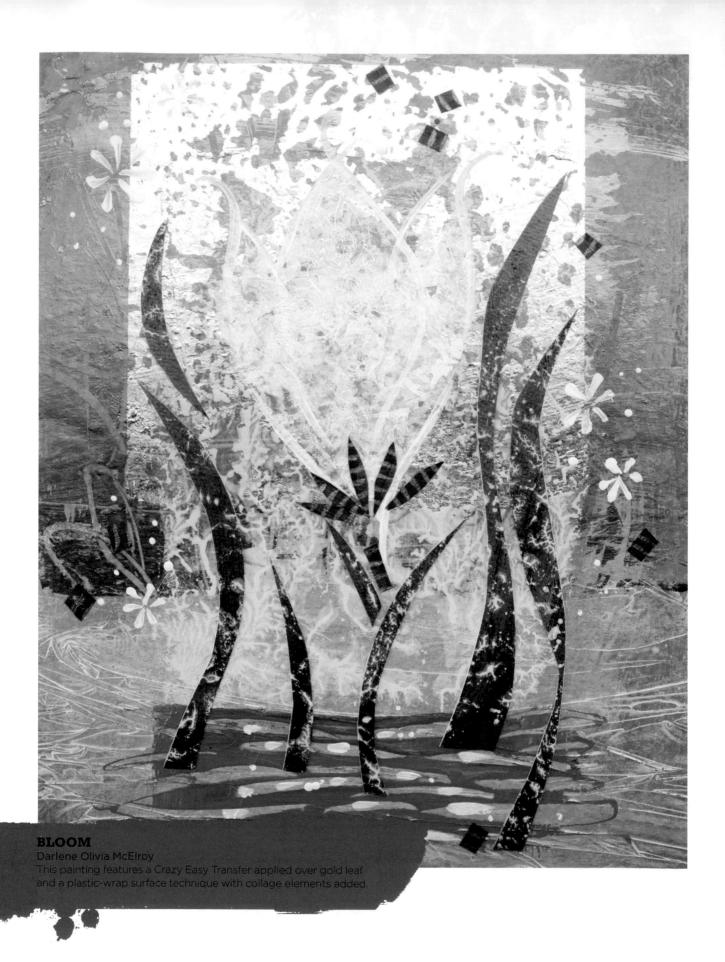

BLOOM
Darlene Olivia McElroy
This painting features a Crazy Easy Transfer applied over gold leaf and a plastic-wrap surface technique with collage elements added.

TECHNIQUE TWO: COLLAGE PAPERS 101

This is an inexpensive way to create beautiful collage papers using deli sandwich paper. You can buy deli papers by the box at restaurant supply stores or big box stores. Or maybe your local deli would give you a few to get started.

1 Mix your paint with some gel medium.

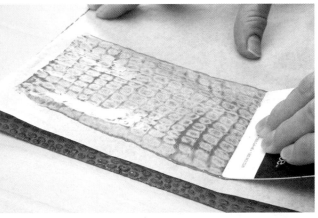

2 Place the deli paper over a textured surface. Create texture on the deli paper by spreading the paint mixture over patterned paper with a palette knife or old credit card. If you prefer a smooth surface, apply the mixture over a texture-free surface.

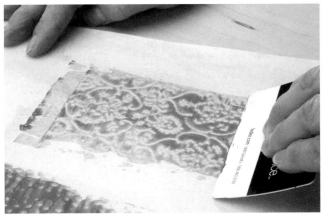

3 You can play with several colors and even use the finger-painting method as described earlier in this chapter. Let the paint dry.

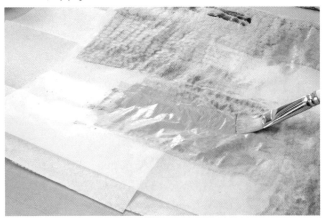

4 You can use your creation as is or flip the paper over and apply a contrasting color to the other side. Deli paper is very thin and the color will show through.

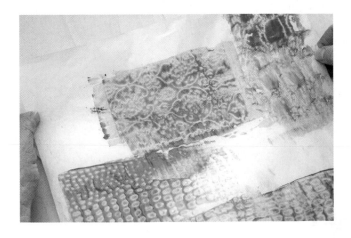

EVERYTHING ELSE

Leveraging your art can lead you down new paths and to new adventures. So far, you've learned everything from how to use your leftovers to techniques to help you conquer your fears. This last chapter includes several other innovative ideas to get your work moving in new directions. What happens when you have reached an impasse with a painting? Do you put it in the closet or bury it in the garage or basement? You'll find several ways to get beyond being stuck or feeling like your piece is a lost cause. And often our artist friends see the potential in a piece with fresh eyes and can lead us in a new direction. Or perhaps your piece is meant to have another life as a mouse pad, cell phone cover or greeting card. In this chapter, you'll learn how to extend the shelf life of your experimental work and how to experiment with different substrates, like aluminum foil, plastic and clay. Listen to your art and it might just tell you where it would like to go. Perhaps a new medium or style is calling you. Listen and dare to dream big!

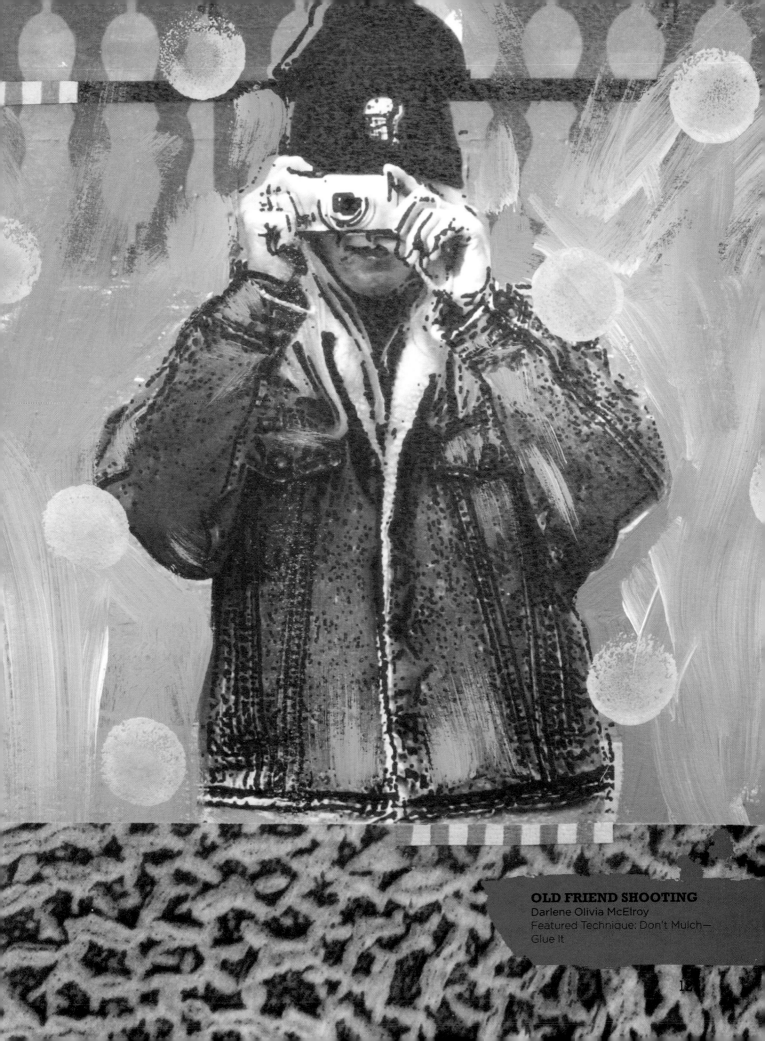

OLD FRIEND SHOOTING
Darlene Olivia McElroy
Featured Technique: Don't Mulch—
Glue It

Forever Yours

I love to experiment with different products, but sometimes the results are unstable and far from archival. What's an artist to do? Scan it! Experiments with bleach pens can get you some wild results but the stuff literally crumbles after just a short time. Crackles are fun, but they can be big fun when you enlarge them. While you are at it, try changing scale or color—your computer can help! Then keep files of your favorites for later use.

TECHNIQUE ONE: MAKE IT LAST

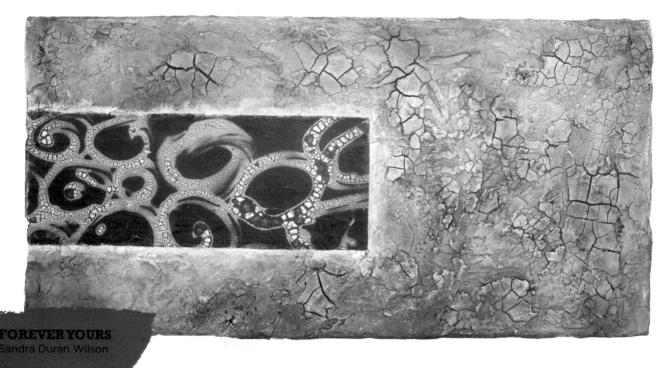

FOREVER YOURS
Sandra Duran Wilson

TIPS

- Scan your fragile or unstable experiments using a home scanner, or take them to your local copy shop.

- Always use the color copy machine, even if you plan to print in black and white. Color printers yield better prints.

- Scan and preserve old or delicate papers. This is a great way to be able to preserve the original.

- You can place your experiments between two pieces of glass or plastic to keep them from falling apart during scanning.

- You can scan dimensional objects to use in two-dimensional works.

TECHNIQUE TWO: BIG FUN

Crackle textures are great, and I love how they look enlarged.

TIPS

- Scan and enlarge your crackle experiments.

- Try playing with the contrast and the color.

- Use your printed enlargements in transfers.

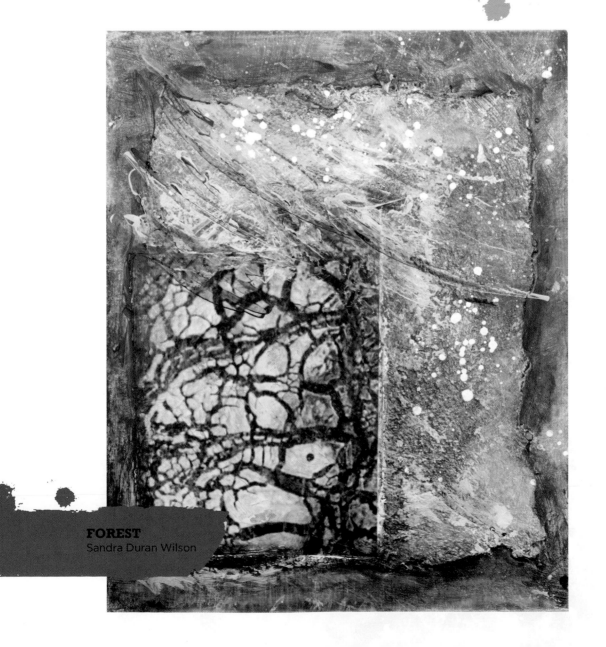

FOREST
Sandra Duran Wilson

Naturally Preserved

Do you have a dried flower that is so fragile it might fall apart if touched? You really want to use it in your art, but you can't turn it into amber, like a bug in tree sap. So what's an artist to do? Let us show you how to do the next best thing: Simply encase your delicate materials between two pieces of tissue paper and seal with polymer medium. This is a good way to create beautiful collage papers to use in your art.

1 Put a plastic bag on top of your work surface. Lay a piece of tissue paper down on the plastic and gently paint the tissue paper with polymer medium that has been slightly diluted with water.

2 Immediately place your fibers or plant materials onto the tissue and arrange as desired. Glue the items down with a little more of the polymer medium mixture if necessary.

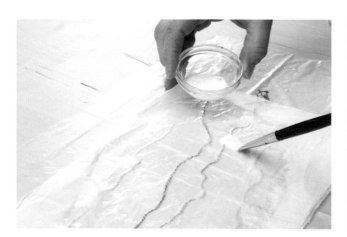

3 While the tissue paper and fibers are wet, place another piece of tissue paper on top, like a sandwich, and apply more diluted polymer medium.

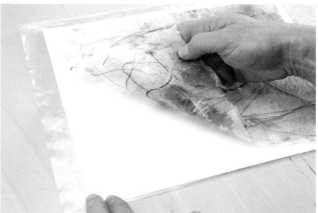

4 Let the paper and medium dry completely. Once it's dry, you can pull your embedded fibers off the plastic.

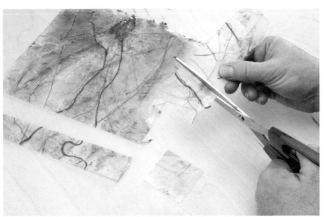

5 Cut into pieces or use as is.

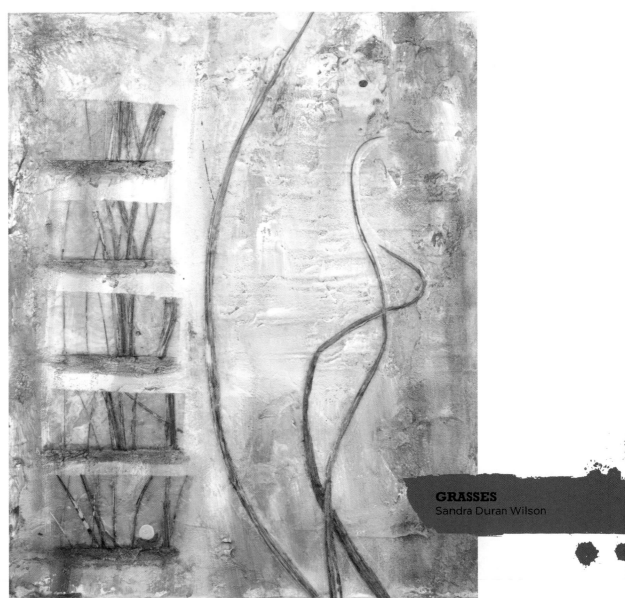

GRASSES
Sandra Duran Wilson

Beyond Trading Cards

Every artist eventually creates a piece that is problematic regardless how much paint they throw at it. You may want to just shove the thing into the back of the closet until you come up with a new idea or solution, but there is a better way—give your art away, at least for a while! Give it to an artist friend and let her play around with it. She will look at it with fresh eyes and find potential you may have overlooked. Who knows? You may find that when you get it back it will lead you on a whole new journey.

TECHNIQUE ONE: ONE ON ONE
Exchange artwork with your artist buddy for a week or two. You'll each add a bit here and a flourish there, and when you exchange the pieces again, you'll see new possibilities for where your art can take you.

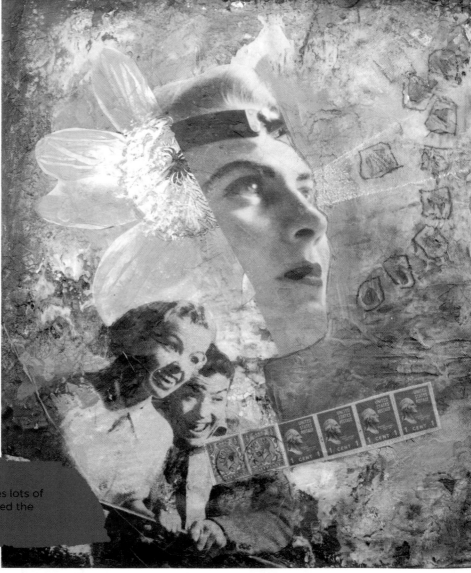

ALTERED CONNECTION
This piece started with Sandra and features lots of textures, crackles and glazes. Darlene added the imagery of flowers, stamps and people.

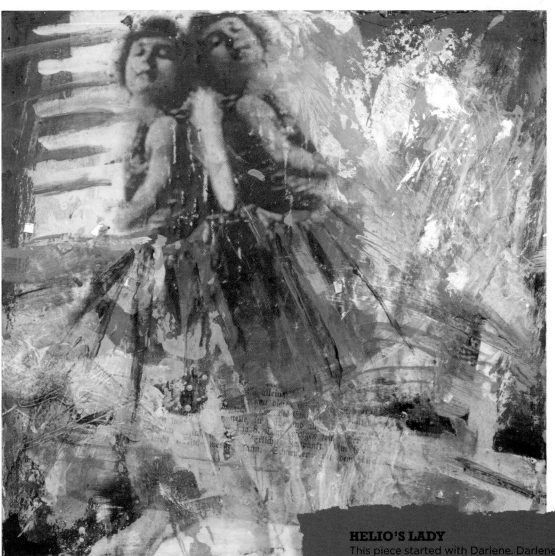

HELIO'S LADY
This piece started with Darlene. Darlene collaged and stamped on top of a background layered with water-slide decals. Sandra then painted over the face on the right and added more texture.

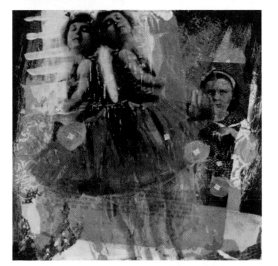

TECHNIQUE TWO: THE ADD-ON VOYAGE

For this technique, you'll need a group of twelve artists and a book, box or painted surface that has sections marked and clearly defined or gridded out. Each artist will start her own unique piece and once a month it is passed to the next artist on the list. Everyone gets to contribute to the final piece.

It really is wonderful to receive a package full of incredible art every month and to expand your horizons by working in many different formats with artists who favor different styles and mediums.

127

Don't Mulch

Do you love the texture of cantaloupe or corn husks? The beauty of a dried datura or lily? The shape of red beans or sliced kiwis? By scanning or copying them, they can all be part of your recipe for a wonderful piece of art.

TECHNIQUE ONE: GLUE IT

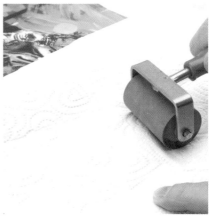

1 Brush your surface with soft gel in the area where you want to place your image. If you will be working with an inkjet image, make sure you spray with a work-able fixative first.

2 Position your image and press to adhere it.

3 Roll over it with a brayer to ensure strong adhesion. Laying a paper towel over your surface will keep soft gel from getting on your brayer.

TECHNIQUE TWO: GRUNGE IT

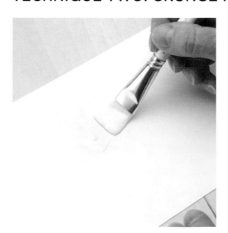

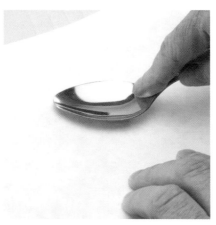

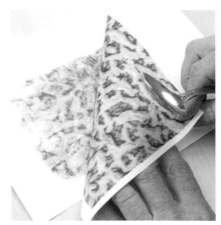

1 Lay down a thin layer of soft gel on your surface.

2 When the paintbrush starts to drag on it, quickly lay an inkjet image face down onto the gel and burnish. This works best with a smooth paper surface.

3 Hum the Jeopardy theme song twice and lift the image off the background. You should be left with an image on the surface that is slightly grungy.

TECHNIQUE THREE: WEAR IT

Can you imagine how cool a kiwi necklace, cantaloupe textured earring or an ornament with star fruit would be? So easy, so much fun and so original.

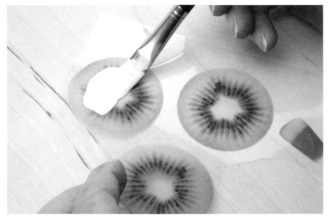

1 Print your images on multipurpose transparency film and paint the printed side, if desired. Seal with polymer medium and let dry.

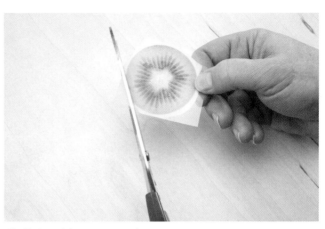

2 Cut out images or shapes.

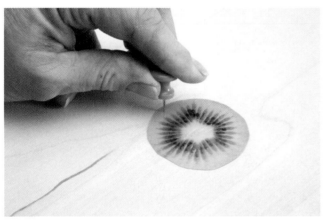

3 To make earrings (or to use your cutouts as beads), punch holes to accommodate jump rings as needed.

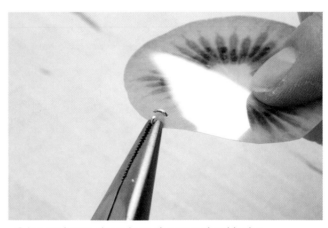

4 Insert jump rings into the punched holes.

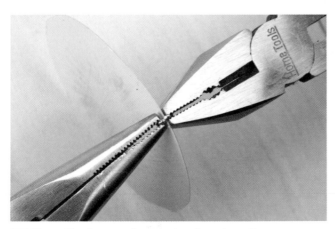

5 Close the jumps rings using jewelry pliers.

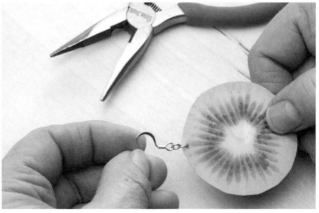

6 Attach the jump rings and transparency shapes onto a chain or earring hook.

Change of Life

Part of being an artist is promoting your work, but who says we're limited to hanging it on a wall or putting it on a pedestal? Here are some unique ideas for showing off your work. You can find plenty of sources online.

Mouse pads—Great as collector gifts to remind people that they like you and your art.

Cell phone or tablet cover—Every time you use them in public, people are going to see your art. There are even sites that will create a wallpaper to match your cell phone art so your entire device displays your art. Very cool!

Pillow covers—This could be a way to get your work into the interior design market.

Clothing—This could be anything from T-shirts to custom-made clothing.

Magnetic car sign—Drive around town and let people know who you are and what you do. Make sure you include your website address. And please, drive safely!

Licensing—License your work with decorators and designers.

Price points—Create a line of work on paper to give you another price point for your art.

Business cards—Always include your art and full contact information on your business card.

Two-sided folding screen or a hanging panel—So your art can be seen coming and going.

Hot Off the Printer

You don't want your techniques to be the focus of your work. You want them to be mysteries that add to the overall aesthetic. After all, if the audience can't tell how you did it, you must be a professional!

TECHNIQUE ONE: SHINE IT
Printed aluminum foil lends a bit of bling and mystery.

MODERN MADONNA
Darlene Olivia McElroy

1 Brush one to two coats of Golden Digital Ground or Inkaid onto aluminum foil.

2 Let the ground dry.

3 Attach foil to a carrier sheet for your inkjet printer—cut it a bit smaller than the copy paper and tape the edges down.

4 Print your image onto the foil and let it dry.

5 Spray the printed foil with a workable fixative.

6 Glue the piece to a surface of your choice—with matte soft gel.

7 Finish your artwork as desired.

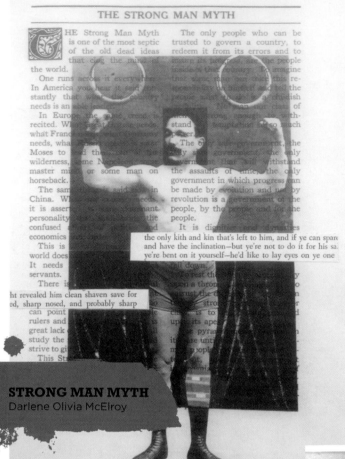

STRONG MAN MYTH
Darlene Olivia McElroy

TECHNIQUE TWO: MAKE IT TALK

Add another layer to your imagery by printing directly on book pages. I especially love images printed on architectural book pages. If your paper is slick, follow steps 1 and 2 from Shine It (Technique One); you'll be painting the Digital Ground or Inkaid on book pages instead of foil.

TECHNIQUE THREE:
MAKE AN IMAGE SALAD

Put a grouping of images or objects—both 2-D and 3-D—on your scanner bed and print (if you have a 3-in-1 printer/scanner), or scan the grouping and then bring the scan into a photo-editing program. Then print it out. Rearrange the objects, and create another image or print.

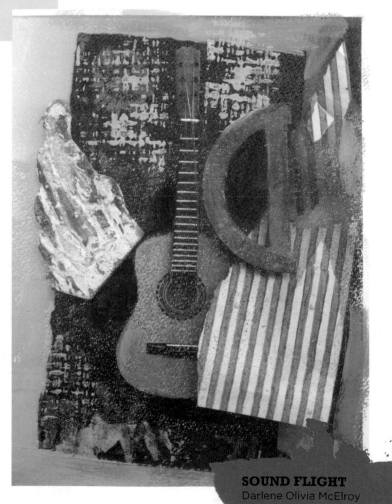

SOUND FLIGHT
Darlene Olivia McElroy

Embrace Me

Have you ever tried to paint onto a sphere or a bowl? It can be a little tricky as you try to hold it and paint at the same time. Here are some easy ideas to help you out and wrap your painting around a three-dimensional surface.

WRAP IT UP

Use the Crazy Easy Transfer technique to transfer your painting onto a sphere. Instead of a painter's tarp, use a thinner plastic, such as plastic food wrap, a dry cleaning bag or a plastic produce bag. This is a good way to recycle all those bags.

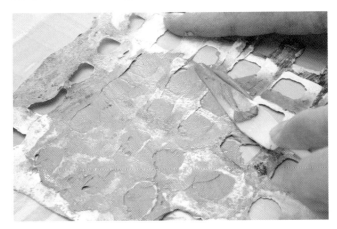

1 Paint, stamp or stencil directly onto the plastic and allow it to dry completely. In this demonstration, I am using Quinacridone Magenta mixed into light molding paste and applied through a stencil.

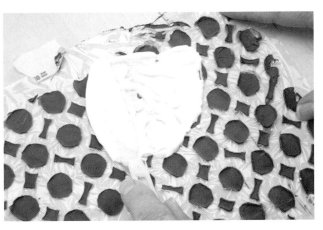

2 Apply soft gel onto the plastic. Make sure you cover the plastic completely with the gel.

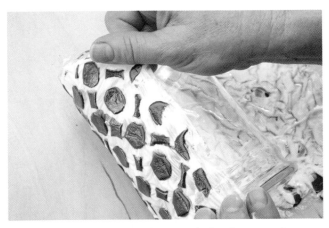

3 Carefully wrap the gel-coated plastic around your object. (Here I'm applying it to a simple glass vase.)

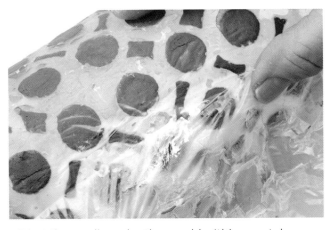

4 Let the medium dry thoroughly (this may take several days) and then carefully pull off the plastic.

TIPS

- A faster way to do this technique is to use waterslide decals—this works especially well with candle holders.

- Use painter's or masking tape to hold the plastic down while you embellish it. The tape will also serve as a visual cue as to which side the paint is on.

For more information on the **Crazy Easy Transfer technique** scan this QR code with your smartphone, or visit createmixedmedia.com/ mixed-media-revolution.

TECHNIQUE TWO: MAKE YOUR OWN DECALS AND STICKERS

So many of the fun things in the hobby stores are intended for children, but we think we should get to share in the fun! For example, we've talked a lot in this book about making and using waterslide decals—but they really are that much fun! If you can't find materials in your local craft store, Google can help you find manufacturers and retailers. Just follow the instructions on the package or check out one of our bonus tutorials.

Grafix is one company that makes decal paper you can print on via your computer. You then peel off the images to make your own stickers. This works really well, and you can use the stickers to personalize a decorative ornament or other glass object. We've used Grafix in this demonstration.

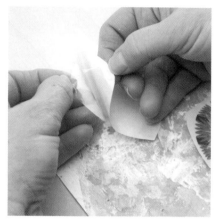

1 After you have printed your image onto the Grafix paper, attach the paper to the adhesive backing. Burnish and then remove the backing paper from the image.

2 Press the image onto your surface.

3 Burnish and then peel off the top layer of plastic.

TAKE 4
Sandra Duran Wilson

TIP
Remember, the steps in this process may differ depending on which manufacturer's product you use. Be sure to follow the instructions for your particular product.

For more information on **making and using waterslide decals**, scan this QR code with your smartphone or visit createmixedmedia.com/ mixed-media-revolution.

Dare to Be Different

Expand your mind-set, experiment and grow. If you are an abstract artist, try a realistic painting, and vice versa. Give your brain cells a workout. Research shows if you challenge your mind by trying something different than what you normally do in life, you generate new brain cells. It may be a struggle at first, but I bet by the time you are finished, you will have learned a lot.

TECHNIQUE ONE: REALISTIC TO ABSTRACT

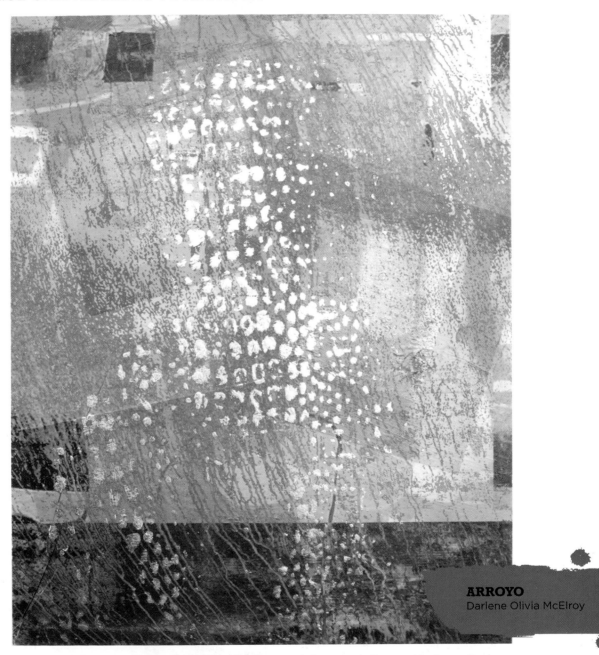

ARROYO
Darlene Olivia McElroy

This is a good time to practice techniques like finger painting or splatters and textures. Begin by creating the background and shapes for your realistic painting, and stop. You have the large shapes and a few color values. Now develop this as an abstract work rather than adding the details. If you are feeling stumped, take a photo of a scene or figure and squint at it. It will become blurred and distorted. Paint it like you see it. You can also do a similar thing with the blur tool available in most photo-editing programs. And have fun!

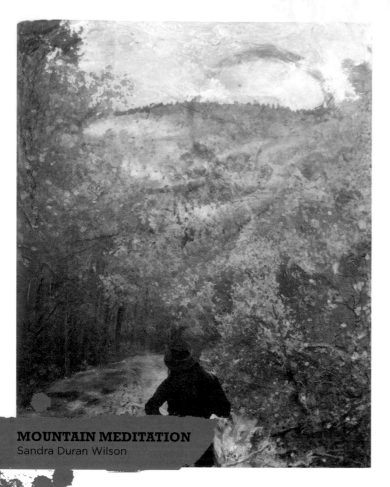

MOUNTAIN MEDITATION
Sandra Duran Wilson

TECHNIQUE TWO:
ABSTRACT TO REALISTIC

This is your chance to play with the photos you've taken or to get into drawing. You can try transfers or tracing if you doubt your drawing skills, but try this trick first: Take the image that you wish to draw realistically and turn it upside down. Begin by drawing one line to the next. Don't think about the whole picture. Your brain will trick you into seeing only shapes, and you will find that, yes, you can draw.

TECHNIQUE THREE:
A BIT OF BOTH

You can do a combination of the prior two variations. If you are an abstract painter try adding shadows to a shape in your painting to give it an area of depth and realism. If you are a realistic painter, try leaving out most of the details in one area or even eliminate some shapes. Have fun and try new things.

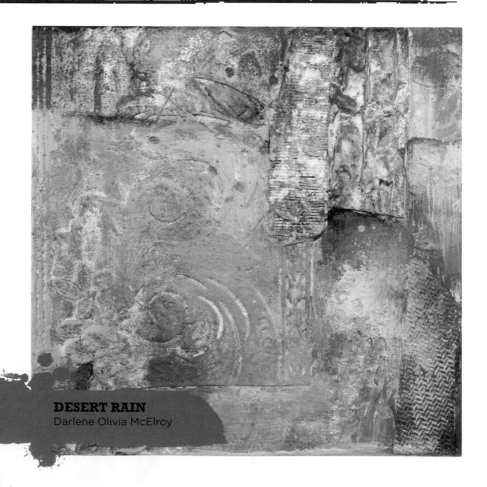

DESERT RAIN
Darlene Olivia McElroy

Work in New Media

We love trying out new products, surfaces and techniques. And, of course, we are always trading new tips and techniques with our friends. That is the beauty of art. The ideas are endless. YouTube videos can even spark ideas.

TECHNIQUE ONE: BE A GRAFFITI ARTIST

Here's your chance to get a taste of the street art trend. You can buy spray paint, make stencils and climb tall buildings; or you can try these tricks in your studio. You can purchase small cans of spray paint, or try Preval, a reusable spray paint container sold at big box home supply stores.

1 Tape a stencil onto a piece of canvas or panel.

2 Working outside, spray paint through the stencil.

3 You can overlay stencils and words to add a bit of edginess to your work.

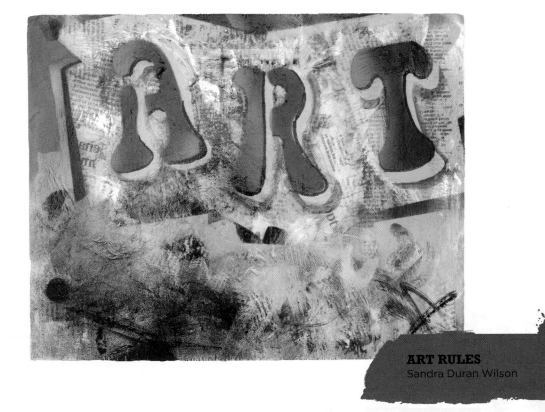

ART RULES
Sandra Duran Wilson

TECHNIQUE TWO: SILKSCREEN ONTO GLASS

Printmaking in glass is a very specialized art form that requires a kiln. The idea we are suggesting is to try a new medium—take a class in something that is completely new to you and become inspired anew!

 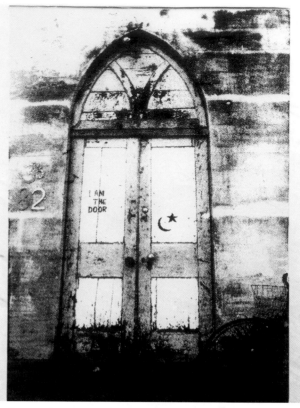

You will need a background image and an image printed on glass. Put the two together, the glass piece on top of the background, and then frame.

TECHNIQUE TWO: ETCH A SKETCH

This is your chance to finally use that Dremel tool you got for Christmas seven years ago.

1 Draw or trace an image onto Plexiglas with a marker.

2 Etch into the Plexiglas with your Dremel.

3 Rub burnt umber acrylic into the lines and immediately wipe off the excess. The paint will remain in the grooves and gouges.

4 You can then paint over the rest of the Plexi.

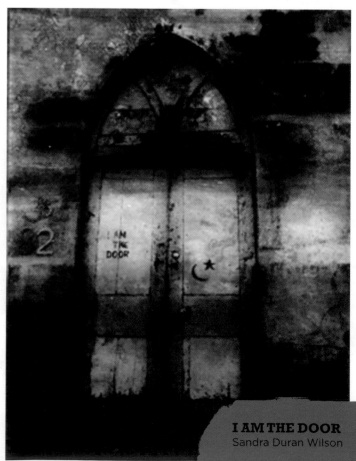

I AM THE DOOR
Sandra Duran Wilson

Resources

ART & HOBBY STORES
 Acrylic paints, gels and gesso
 Golden digital ground or Inkaid
 Gampi paper
 Spray paint
 Stamps and stencils
 Tissue paper
 Water soluble crayons

CANVAS REPRODUCTIONS
 Fineartamerica.com

FABRIC STORES
 Fusible web

PHARMACY OR GROCERY STORE
 Petroleum Jelly
 Aluminum foil

MAGNETS, MOUSEPADS, CARDS
 Zazzle.com
 Society6.com
 Cafepress.com

HARDWARE STORE
 Plastic tarps
 Epoxy

PLEXIGLAS & METAL REPRODUCTIONS
 Acrylicpix.com
 Bayphoto.com

OFFICE SUPPLY STORE
 Transparency film

WATERSLIDE DECALS
 Papillio.com
 Lazertran.com

 To visit the **Mixed Media Revolution companion page**, scan this QR code with your smartphone or visit createmixedmedia.com/mixed-media-revolution.

About Sandra Duran Wilson

Sandra Duran Wilson is influenced by scientific concepts, the dream state and the nature of materials. She loves to experiment and push the limits of paints, mediums and surfaces. She enjoys the tactile aspect of paint and what it can do, and she has always been an inventor of new ways to use existing tools and materials. She loves to paint ideas; to make them visible, beautiful and abstract so that others may enter them and create their own reality. She lives and creates in Santa Fe, New Mexico, with Mark, her husband and collaborator, and a bevy of feline friends.

For easy-to-use **links to Sandra's website, Facebook page and more**, scan this QR code with your smartphone, or visit createmixedmedia.com/ mixed-media-revolution.

DEDICATION:

To my mom, Betty, who has always believed in me. For Mark, my soul completion, and to my grand-parents, who taught me early in life how to make use of everything I am given.

ACKNOWLEDGMENTS:

Thank you to Tonia Davenport for getting this book on board and always supporting our ideas and projects. Tonia helped us to shape this book into its current form from our early concepts; Kristy Conlin, our fabulously talented and fun editor; Christine Polomsky, our gifted photographer, you always make us look good and laugh through all the work. To all the F+W team, thank you for the wonderful work that you do. You are all such talented folks.

We would like to thank our fellow artists, our critique group, art collectors and, of course, all of our students who keep us looking for more fun things to write about.

About Darlene Olivia McElroy

Darlene Olivia McElroy comes from an old New Mexico family of storytellers and artists. She began making art the first time she found a wall and a drawing instrument. Her grandfather, a painter on Catalina Island, was her mentor and taught her to play and experiment with art. Darlene attended the Art Center College of Design in Pasadena, California, and has worked as an illustrator both in the United States and in Paris. She went from creating illustration traditionally to becoming one of the first nationally recognized digital illustrators in the late 1980s. Darlene lives and works in Santa Fe, New Mexico, where she paints, teaches, writes and enjoys a delightfully chaotic life with her husband, Dave, and their four dogs, Bernie, Bella, Taco and Zola.

For easy-to-use **links to Darlene's website, Facebook page and more**, scan this QR code with your smartphone, or visit createmixedmedia.com/mixed-media-revolution.

DEDICATION:

To Dave, my loving husband and centering force. Thank you for your support and for inspiring my dreams in color. To Bonnie Teitelbaum and the Blonde Bombshells, whose creative and fun influence always shows up in my art.

ACKNOWLEDGMENTS:

Big thanks to our critique group who added their touches to our Pass it Around project and lived through our travels of creating a book.

On the incredible F+W team, we would like to thank Tonia Davenport for getting this book on board; Kristy Conlin, our wild and crazy editor; and Christine Polomsky, our talented photographer. You all made it fun and easy once again.

We would also like to thank our students, who gave us the inspiration to create this book. You kept us exploring and experimenting, and we hope to keep coming up with more innovative ways to play.

Index

16 15 14 13 5 4 3 2

DISTRIBUTED IN CANADA BY FRASER DIRECT
100 Armstrong Avenue
Georgetown, ON, Canada L7G 5S4
Tel: (905) 877-4411

DISTRIBUTED IN THE U.K. AND EUROPE BY F&W MEDIA INTERNATIONAL
BRUNEL HOUSE LTD, NEWTON ABBOT, DEVON, TQ12 4PU, ENGLAND
TEL: (+44) 1626 323200, FAX: (+44) 1626 323319
EMAIL: ENQUIRIES@FWMEDIA.COM

DISTRIBUTED IN AUSTRALIA BY CAPRICORN LINK
P.O. Box 704, S. Windsor NSW, 2756 Australia
Tel: (02) 4577-3555

ISBN-13: 978-1-4403-1871-9

fw media
www.fwmedia.com

Edited by Kristy Conlin
Designed by Rob Warnick
Production coordinated by Greg Nock
Photography by Christine Polomsky
Author photos by Clare Lighton

metric conversion chart

to convert	to	multiply by
inches	centimeters	2.54
centimeters	inches	0.4
feet	centimeters	30.5
centimeters	feet	0.03
yards	meters	0.9
meters	yards	1.1

To visit the **Mixed Media Revolution companion page**, scan this QR code with your smartphone or visit createmixedmedia.com/mixed-media-revolution.

Want to be a Part of the Revolution?

Looking for more? We have tons of FREE **Mixed Media Revolution** companion content to inspire you! Have a smartphone with a QR code reader? Just scan the code to the left for access to technique tutorials covering everything from creating and using gel and waterslide decals to rusting elements, tips and variations for a variety of techniques, background information on the authors and their other books, and videos and photographs.

THESE AND OTHER FINE NORTH LIGHT MIXED MEDIA PRODUCTS ARE AVAILABLE FROM YOUR LOCAL ART AND CRAFT RETAILER, BOOKSTORE AND FAVORITE ONLINE SUPPLIER. VISIT OUR WEBSITE AT CREATEMIXEDMEDIA.COM.

createmixedmedia.com

- Connect with your favorite artists.

- Get the latest in mixed media inspiration, instruction, tips, techniques and events.

- Be the first to get special deals on the products you need to improve your mixed media endeavors.

These and other fine North Light mixed media products are available at your local art & craft retailer, bookstore or online supplier. Visit our website: CreateMixedMedia.com.

Follow CreateMixedMedia for the latest news, free demos and giveaways!

Follow us !
@CMixedMedia

Follow us !
CreateMixedMedia